AWKWARD FAMILY HOLIDAY PHOTOS

AWKWARD FAMILY HOLIDAY PHOTOS

MIKE BENDER & DOUG CHERNACK

THREE RIVERS PRESS • NEW YORK

Three Rivers Press and the Tugboat design are registered
trademarks of Random House LLC.

Library of Congress Cataloging-in-Publication Data
Bender, Mike.
Awkward family holiday photos / Mike Bender and
Doug Chernack. — First edition.
p. cm
1. Holidays—Humor. 2. Festivals—Humor. 3. Portrait
photography—Humor. I. Chernack, Doug. II. Title.
PN6231.H547B46 2013
818'.602—dc23 2013020383

ISBN 978-0-307-88813-6
eISBN 978-0-307-88814-3

Printed in the United States of America

Book design by Maria Elias
Cover design by Nupoor Gordon
(based on original design by Daniel Rembert)
Cover photographs (clockwise from left):
Rhett Lowry, Josh L. Crump, anonymous

2 4 6 8 10 9 7 5 3 1

First Edition

This book is dedicated to all the family members we never see except during the holidays.
We may not always remember your names, but it doesn't mean we don't enjoy your company.

Contents

AWKWARD FAMILY HOLIDAY PHOTOS

Introduction

Throughout the year, we take time out to recognize those momentous occasions known as holidays. While each holiday is tied to its own unique customs and traditions, all of them share one thing in common. They are a time for the whole family to come together to eat, drink, and, of course, pose for uncomfortable photographs. From Mom's homemade Halloween costumes to re-creating a nativity scene for the Christmas card to that overly patriotic uncle who literally wears the flag on the Fourth, holidays are a treasure trove of embarrassing moments. So, with this book, we celebrate the holidays and the awkwardness that bonds us together— matching sweaters and all.

From the time we launched AwkwardFamilyPhotos.com back in May 2009, holiday photos have always been among the most popular and most shared. While we included a holiday chapter in the first Awkward Family Photos book in April 2010, it only scratched the surface. What about the photos of kids being stuffed into pumpkins, depressed Easter bunnies, and families receiving the ultimate Christmas gift—a stripper pole? Yes, these holiday gems needed a place to be memorialized.

As always, this book features popular pictures and captions from the website and also exclusive never-before-seen photos, special features, and "behind the awkwardness" stories from the people themselves. We want to thank all of those amazing families who eagerly send in their most cringe-worthy festive moments year-round. Because of you, every day is a holiday now.

Mike Bender and Doug Chernack
www.awkwardfamilyphotos.com

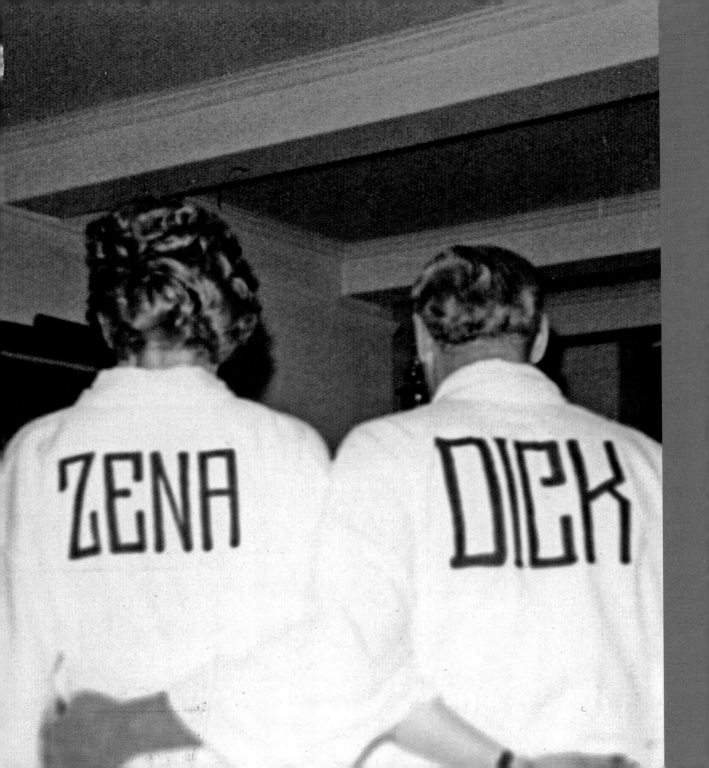

1

Valentine's Day

On February 14, it's not enough for us to simply tell our significant others "I love you." Instead, we're compelled by the romantic pressure of the holiday to prove it—usually with over-the-top demonstrations of passion, which may make our loved ones swoon but in all likelihood make everyone else around us cringe. The idea of matching outfits suddenly seems like a great way to show our compatibility, so we eat breakfast in heart-covered pajamas, but this willingness to embarrass ourselves for amour is what makes our Valentine's Days truly romantic. We don't want to profess our love to our partners with just the same old clichés of chocolates, roses, and cards; we want to do something spectacular. And if we have to look a little awkward while doing so, it's worth it.

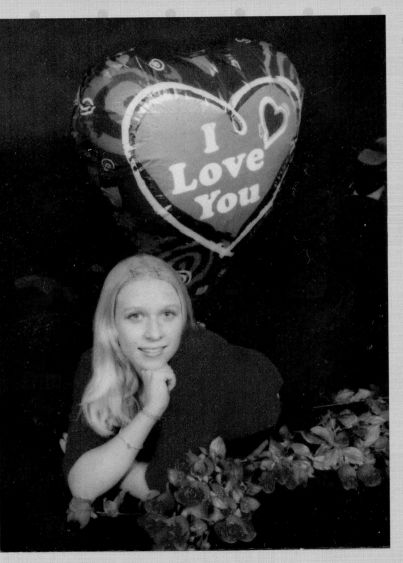

Now all she needed was a Valentine.

LADY IN RED

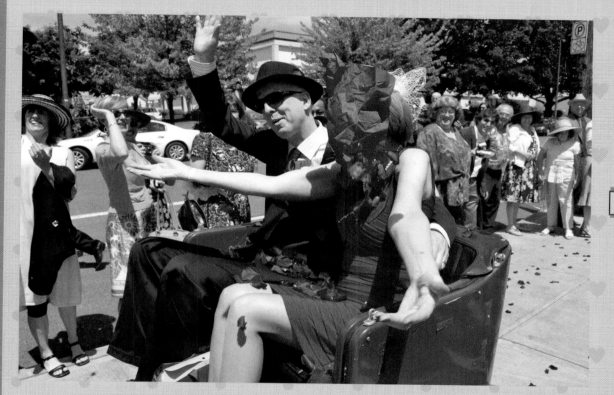

Love is blind.

ONCE BITTEN

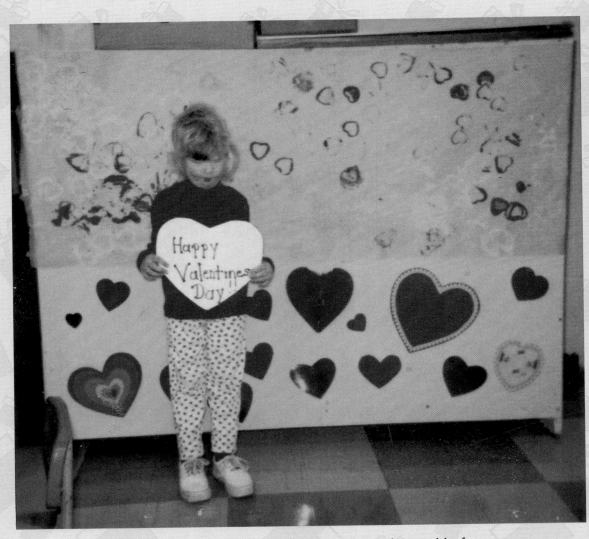

You'll have to forgive her . . . she's been burned before.

IT'S THE CLIMB

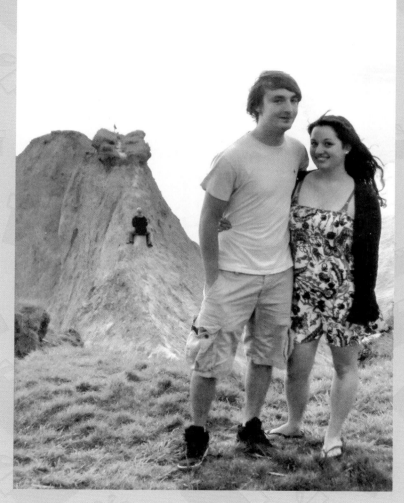

Their love was lifting him higher.

BEHIND THE AWKWARDNESS

My parents were attending a Valentine's Day banquet at church in 1988. They won a gift basket that included a two-night romantic getaway . . . don't let the buttoned-up outfits fool you, because nine months later I was born.

Grace
Hitchcock, Texas

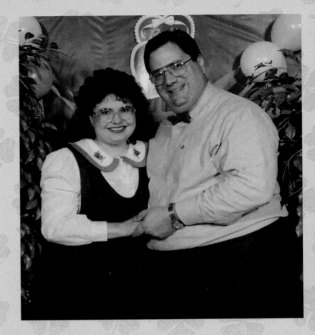

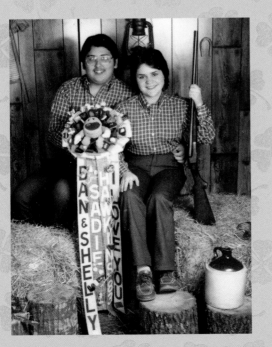

This is my friend Shelly and her husband, Dan. Shelly is wearing the best mom jeans ever, which were not only high-rise, but I suspect she may have buttoned them with her teeth. I believe she and Dan had a twofer coupon not only on the button-down shirts but also on the haircut/ style. Dan had a lovely mum made to commemorate the 1983 Valentine's Day dance. Nothing says love like a shotgun and a stuffed Pac-Man!

Karen
Plano, Texas

THE ROSE

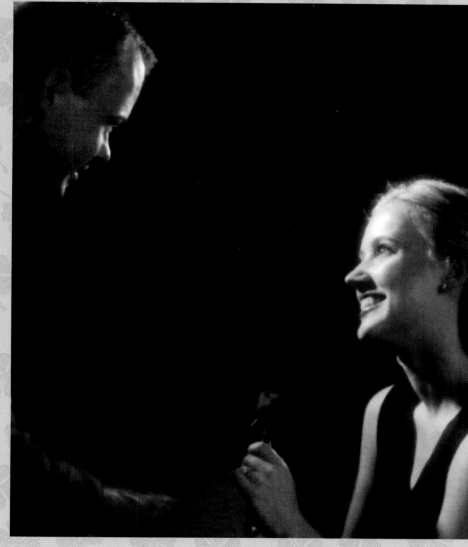

He just stopped by to take it back.

FEED THE METER

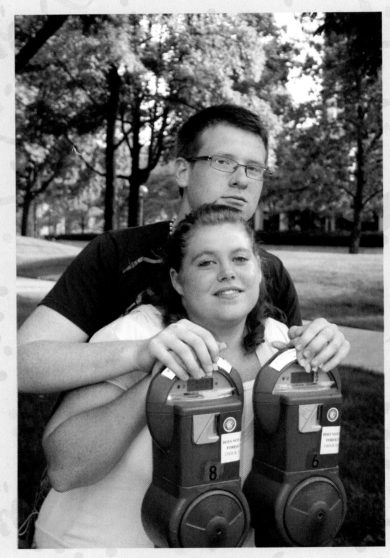

Their love will never expire.

BAGHEADS

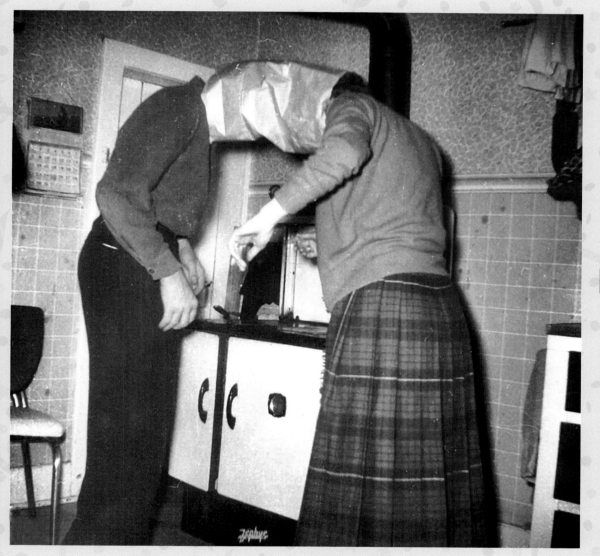

Clearly, "Seven Minutes in Heaven" has evolved.

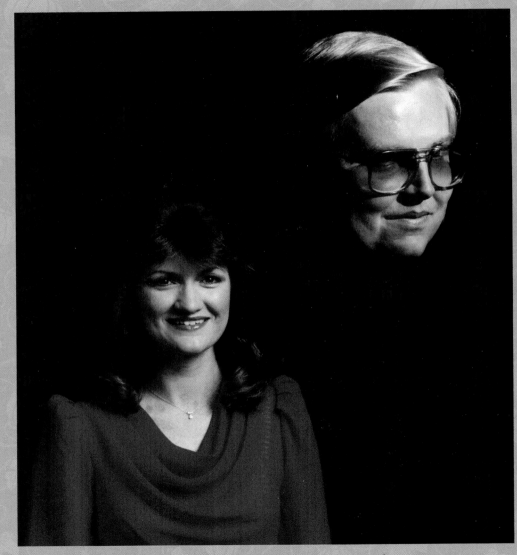

To this day, she swears she doesn't know that man.

LIPSTICKERS

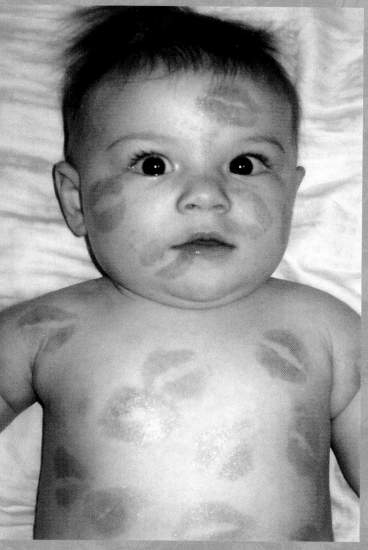

He never saw it coming.

DEEPLY DENIM

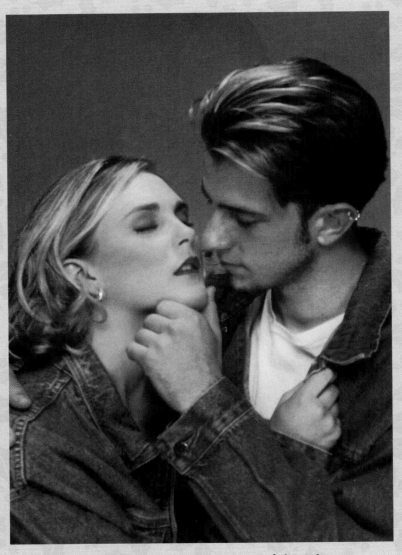

There is no aphrodisiac as powerful as denim.

THE LOOK OF LOVE

As long as you feel the love, there's no need to show it.

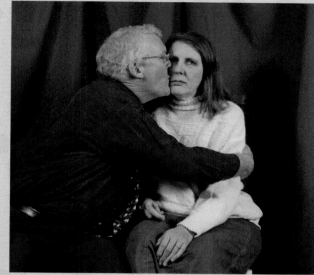

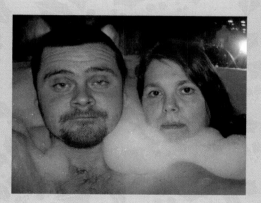

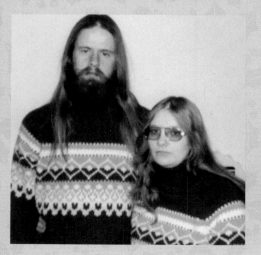

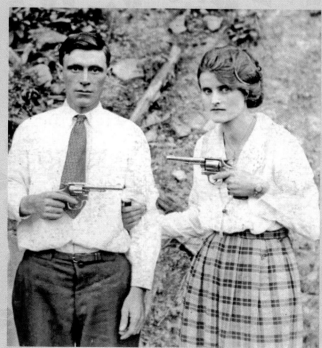

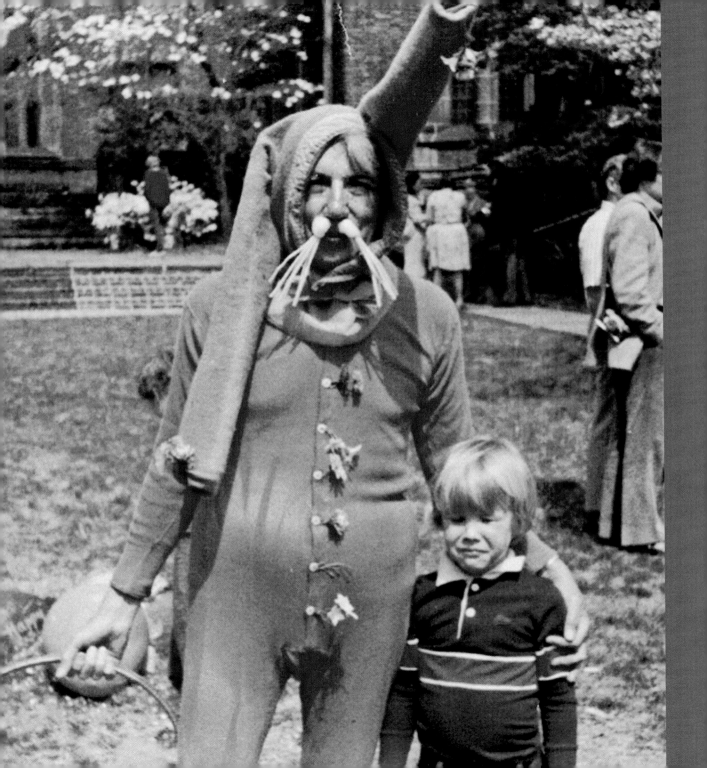

2

Easter

Easter is by far the most perplexing holiday. We dress up in our Sunday best of pastel bonnets, head-to-toe floral patterns, and overly starched suits. We scramble through bushes and up trees to compete with other kids for the ultimate prize: a basket full of eggs. What's more confusing is that when we ask who's responsible for the eggs, we're told it's a bunny. Before we can question the biology of it all, our parents take us to the mall to meet the famous egg-layer. Unfortunately, the cute and cuddly cotton-tailed bunny of our dreams turns out to be a nightmarish full-grown man dressed as a freaky, evil-faced rabbit or perhaps some other kind of unidentifiable creature. As we leave his lap shaking with terror, we're given just enough chocolate rabbits, jelly beans, and marshmallow Peeps to make us stop asking questions.

NOSE CANDY

For some, the hunt had only just begun.

BUNNYBACK

"There must be a perfectly good explanation for this," thought nobody.

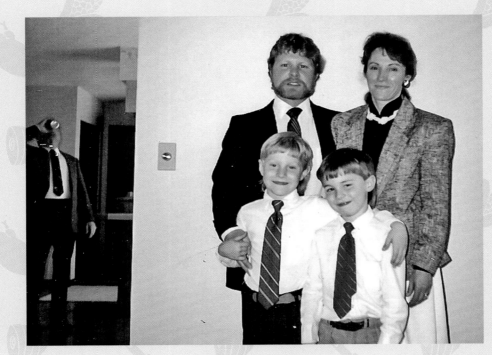

BEHIND THE AWKWARDNESS

This is a picture of my family on Easter sometime in the '90s. I'm on the right with the stonewashed pink pants and a mullet to match my older brother's, but the awkward part of the photo has to be my grandpa in the next room slamming his first Easter beer of the day because we always took our pictures before church.

Phil
Toledo, Ohio

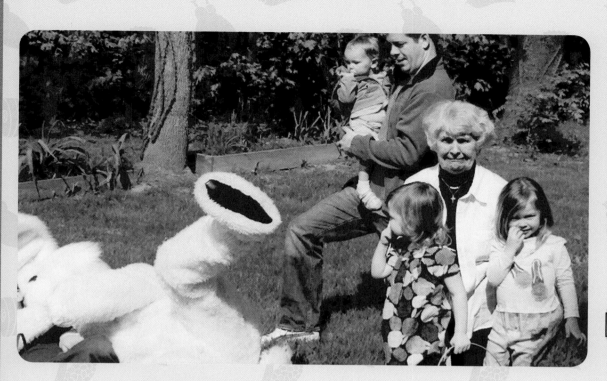

31

We were setting up for our official Easter photo-op
when the bunny (my cousin) lost his balance while
holding my other cousin and took a "bunny flop." In
the mass confusion, the kids thought it would be a
good time to pick their noses while my grandma was
apparently very perplexed by the situation.

Dana
West Terre Haute, Indiana

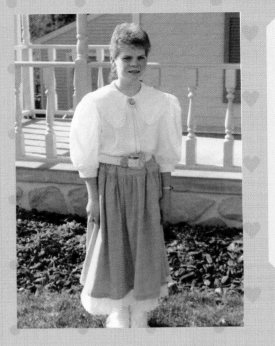

At the time, I was sporting an unfortunate mullet and matching perm; then I got hit in the eye by an errant softball. To cheer me up, my mom apparently decided to dress me up as Annie Oakley for Easter. I guess she thought the combination of leather, lace, and fringe would distract from everything above the neck . . . it didn't.

Shara
Fort Wayne, Indiana

This is a photo of my cousin and me about ten years ago. I was about eleven, a giant, awkward thing who had yet to get braces. For some reason, while walking around at the mall my mother and aunt spontaneously thought it would be a grand idea to force us to get Easter pictures. The photographer put us in half a bunny carcass and bunny ears, and voilà!

Solanah
Vancouver, Washington

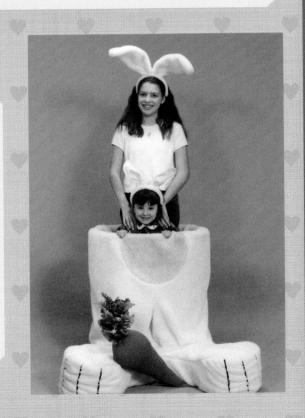

My parents used to party every Saturday night. Clearly, it didn't matter if it was the night before Easter.

Carol
Farmington Hills, Michigan

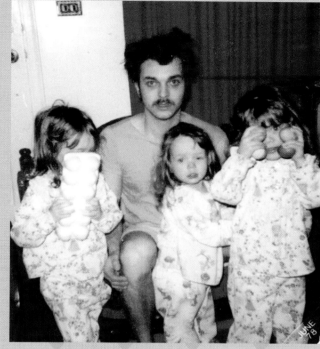

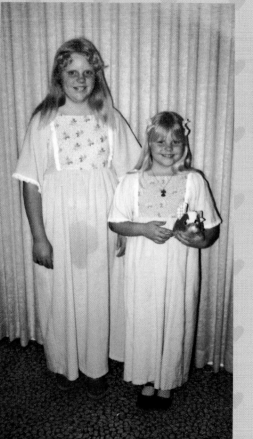

It was Easter Sunday 1975. My mom made us matching Easter dresses every year, and this was actually my favorite of the lot. As usual, I had spilled something on myself during breakfast, so we had to spot-clean it before going to church. My dad wanted to get a picture of us before we left, and he assured me the spot wouldn't show. Turns out I looked a lot more excited to see the Easter Bunny than expected.

Kirsten
Denver, Colorado

SWINGER

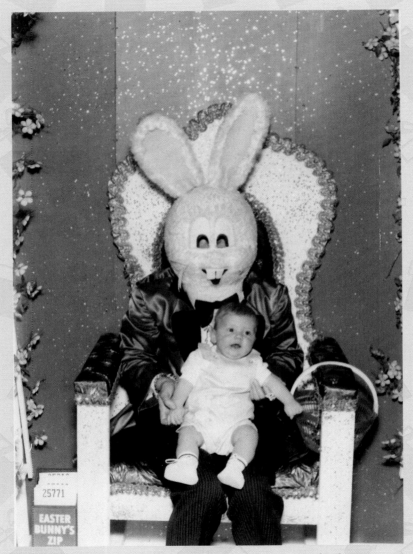

EASTER
BUNNY'S
ZIP

25771

This bunny was channeling his inner playboy.

A SEPARATE·PEACE

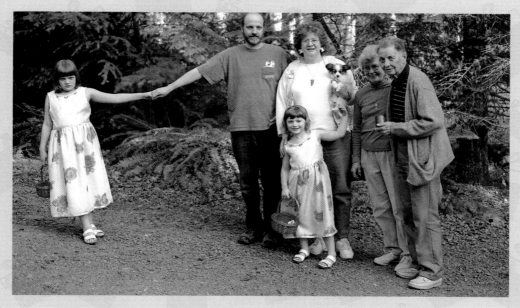

Easter is a time for the whole family to come together.

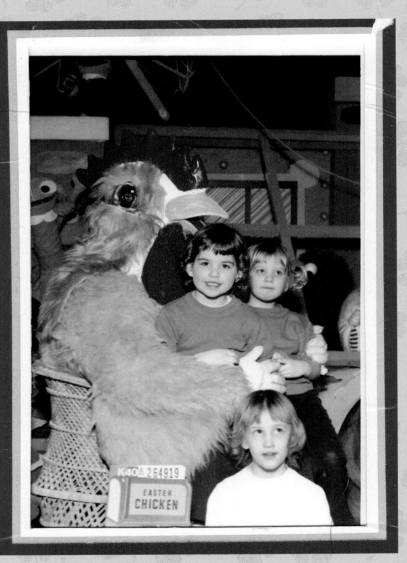

Where do you *think* the eggs come from?

THE MASCOT

It's a living.

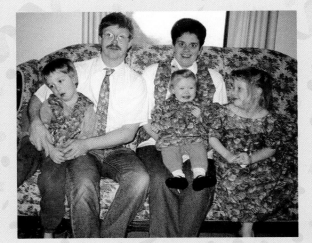

SUNDAY BEST

Our parents tell us to look our best, so why does it feel like we could look so much better?

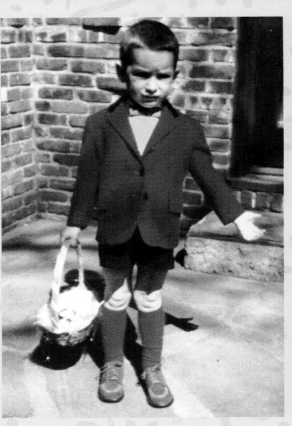

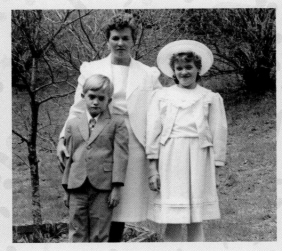

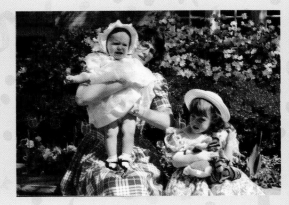

RISE AND SHINE

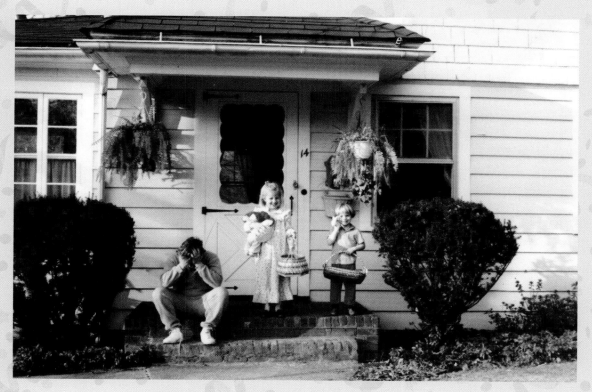

Dad wasn't a Sunday-morning person.

RABBIT TRICK

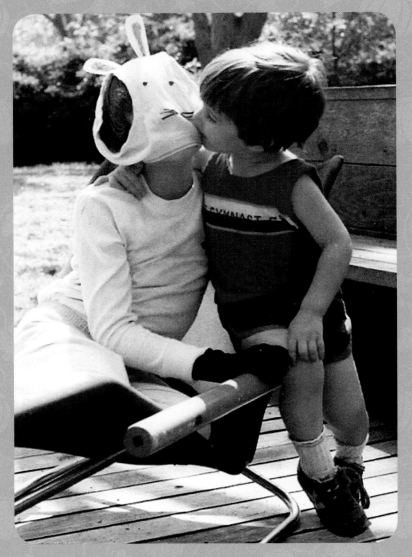

A testament to the power of imagination.

POKER FACES

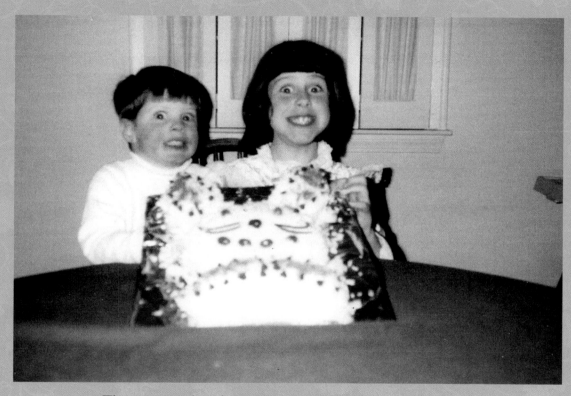

They swear they haven't eaten their Easter candy yet.

REFLECTIONS

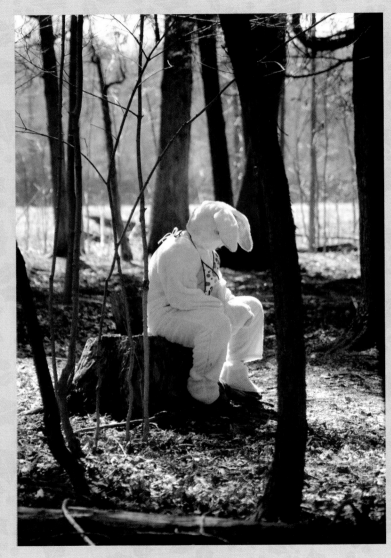

Even the Bunny has a bad day.

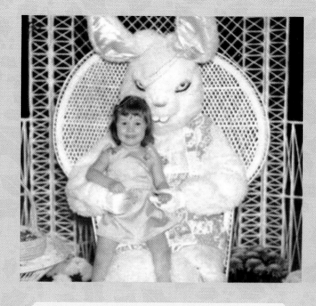

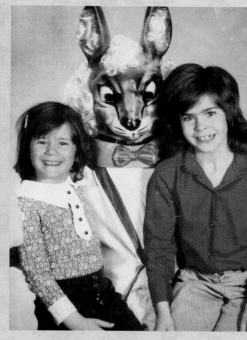

SILLY RABBIT

AFP honors the Easter Bunny, a
mascot clearly open to interpretation.

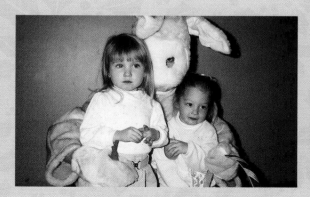

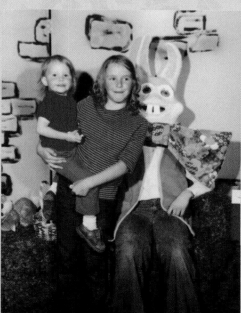

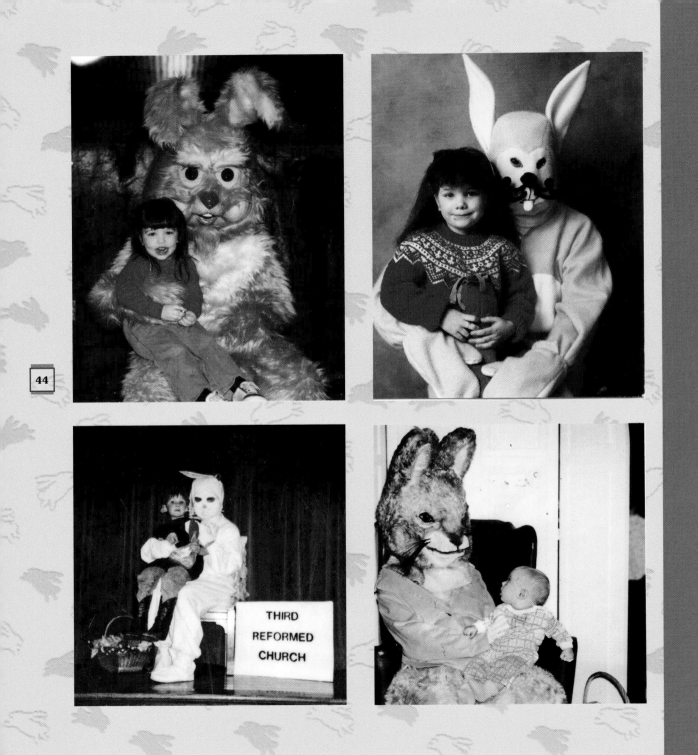

THIRD
REFORMED
CHURCH

44

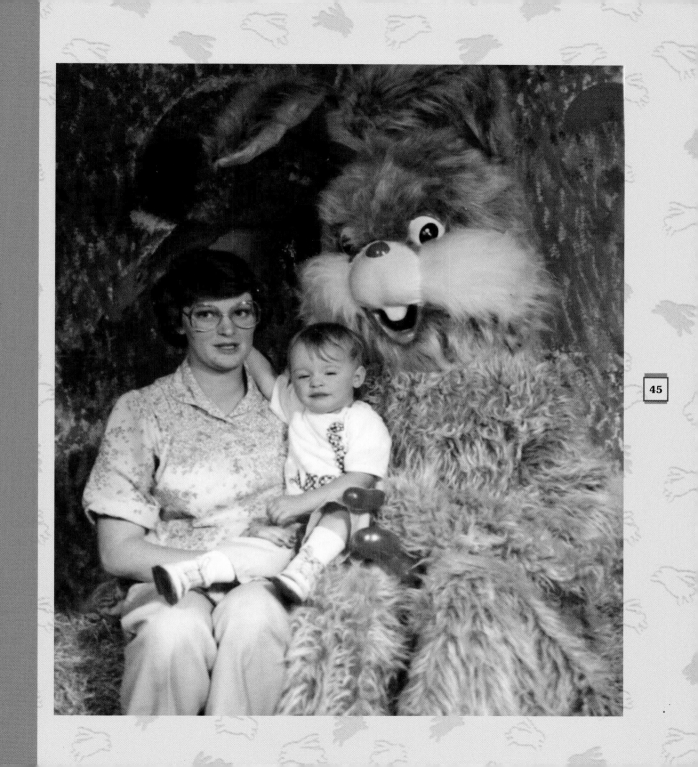

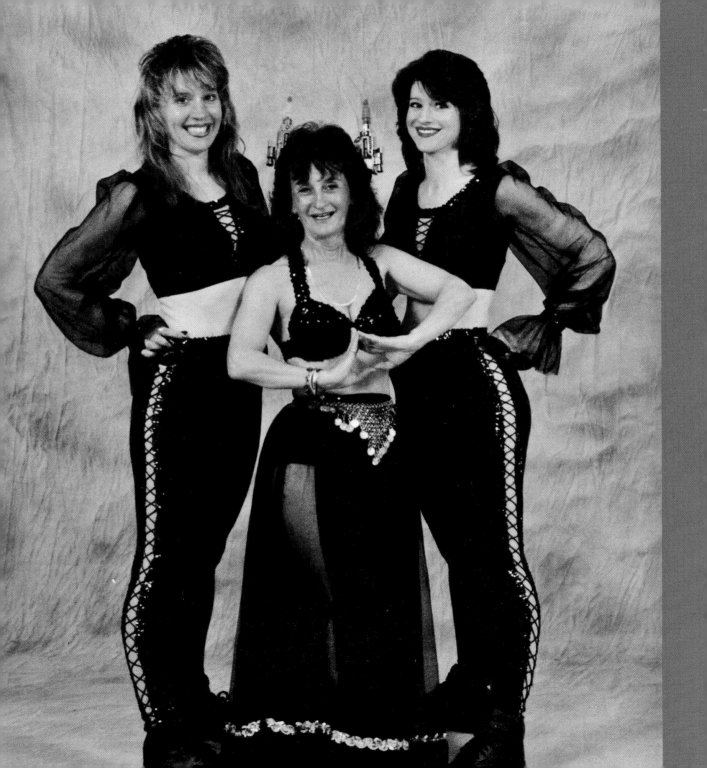

3

Mother's Day

She brought us into this world (as she often "casually" reminds us), and on Mother's Day, we celebrate her for it. We bring her breakfast in bed, give her handmade cards, and tell her, "Today you can do whatever you want," knowing that this means we're probably going to be spending the day at an antique show. We hold our tongues and overlook the things that usually embarrass us—from the lipstick on her teeth and her inability to use a cell phone to the eyeglasses that take up half of her face and the outfits that were appropriate ten years ago. We suck it all up, because we've got the rest of the year to cringe at Mom.

TOGA PARTY

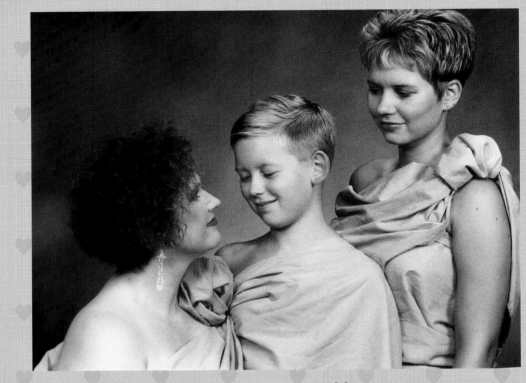

Here's staring at you, Mom.

IN YOUR FACE

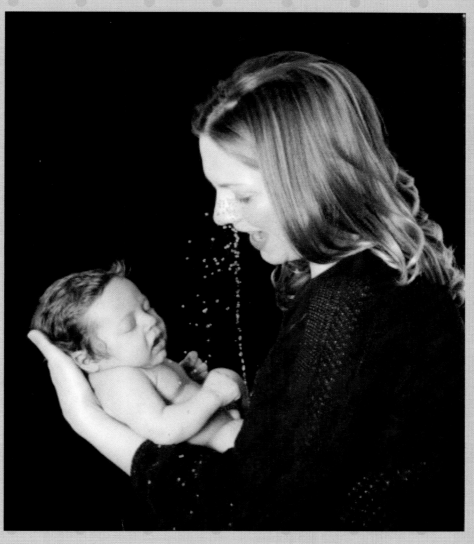

He just wanted to show his appreciation.

DIRTY LAUNDRY

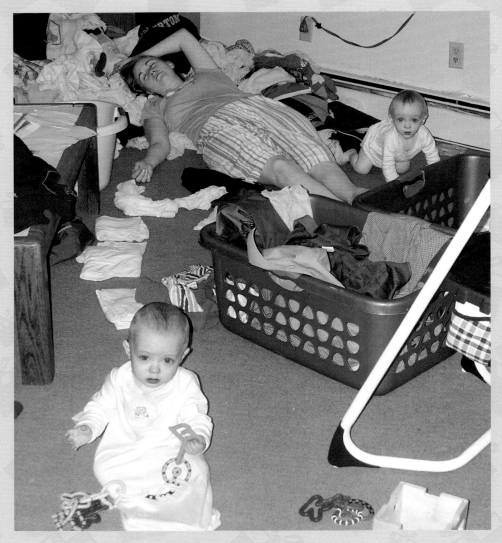

Even Mom deserves a day off.

ROCKY MOUNTAIN HIGH

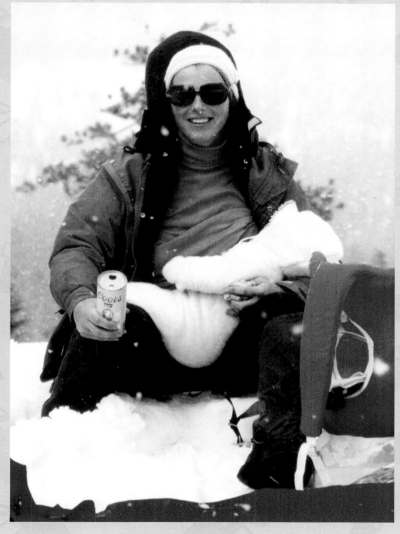

It makes a good chaser.

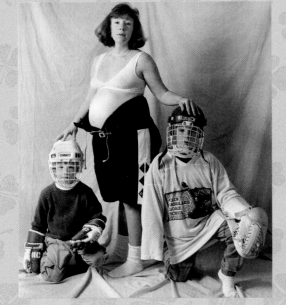

KNOCKED UP

Pregnancy is one of the most intimate experiences for a woman, so why not sketch it, slam it, and slap-shot it for all the world to see?

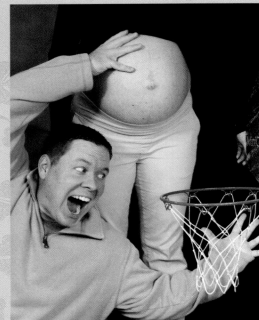

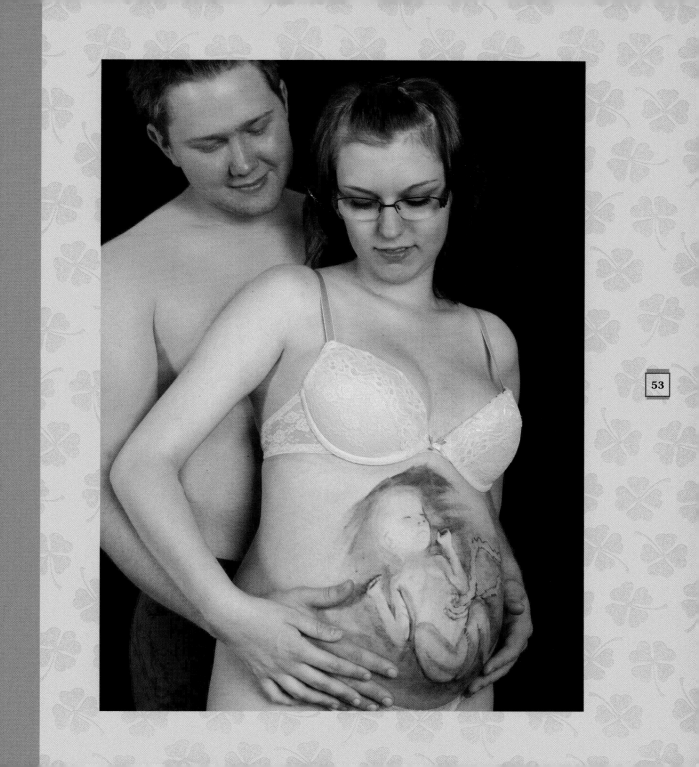

QUEEN BEE

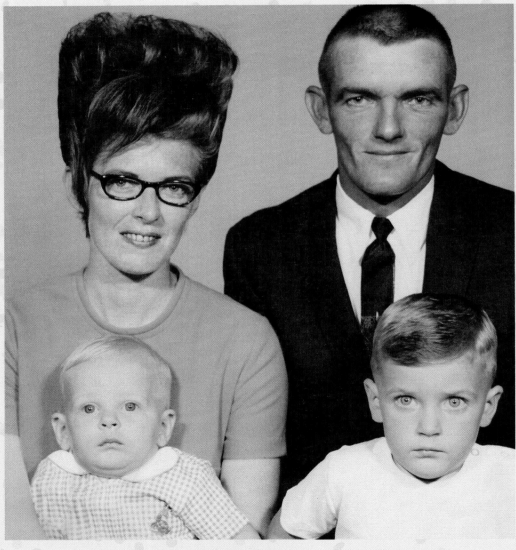

She was the head of the family, but just by a hair.

IF YOU FALL OFF THIS HORSE . . .

You do not get right back on.

TIGER MOM

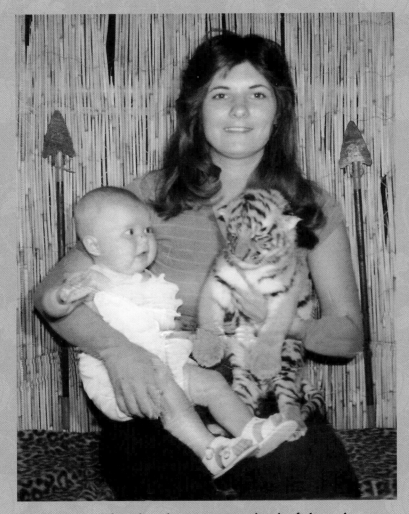

Every mother has her own method of discipline.

THE CLEARING

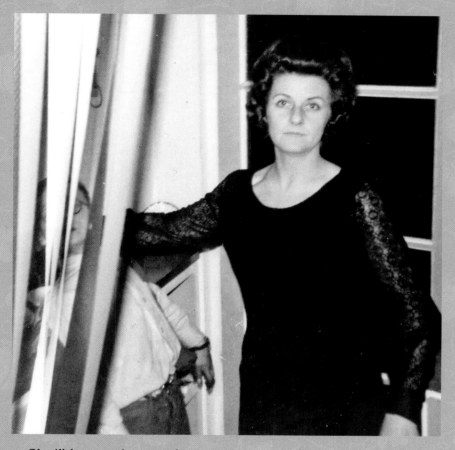

She'll let you know when you're ready for your close-up.

DOUBLE VISION

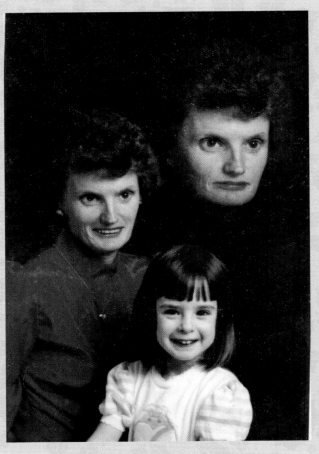

She's always the first thing on her mind.

ROLE MODEL

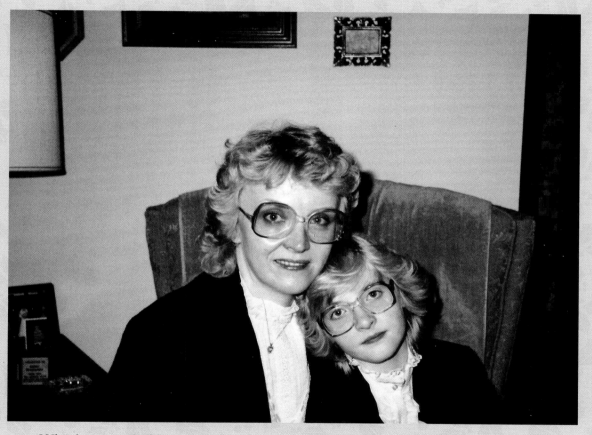

Why be exactly like her someday when you can be exactly like her today?

SUPERSTARS

Whether they're vogueing, jazz-handing, or leading the pack, nothing is fiercer than the mother-daughter combo.

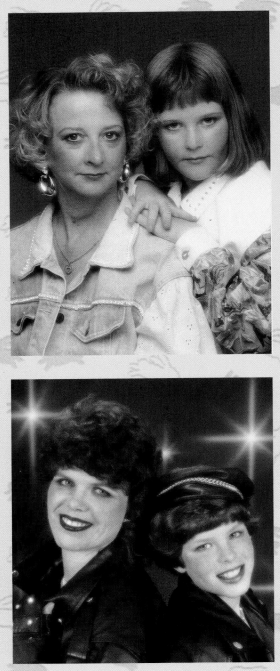

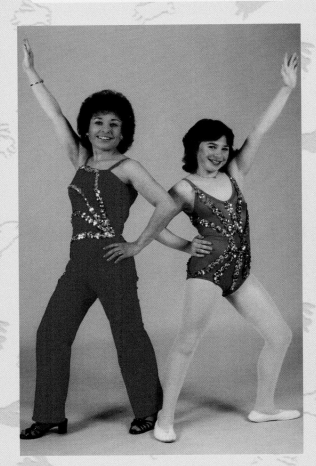

SLINKY

Mom's there for our first steps.

JERSEY GIRLS

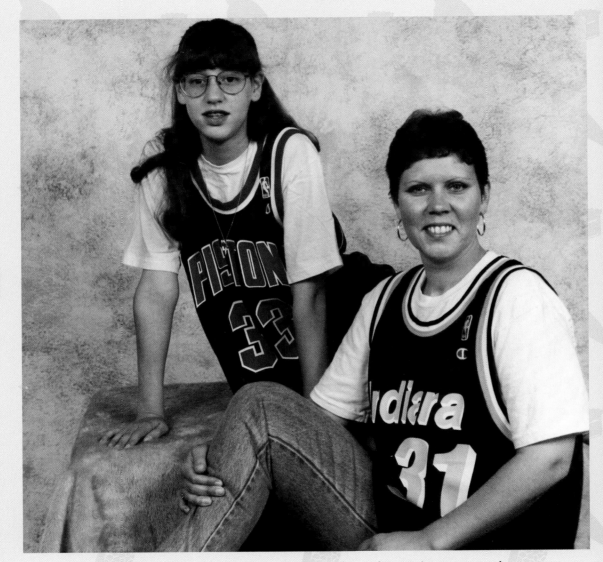

She's your biggest fan and also a fan of your biggest rival.

MOM-FU

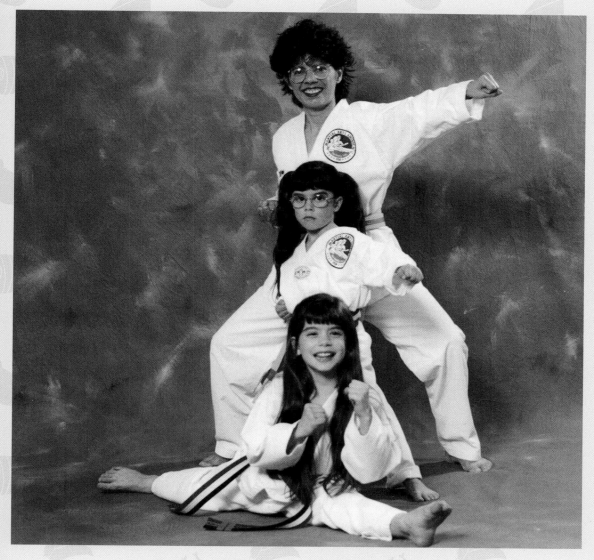

She's the first one to come to our defense.

MOTHER

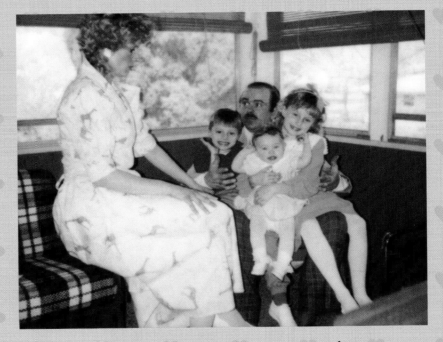

Wearing the pants only gets you so far.

Dear, Mom
I love you.
I'm sorry wen my
feet are folowing you
arownd and mesing
up the house.
I'm sory wen I'm mean.
I love you very
much. if I had the
money I wod buy
you a, Lot of cars,
another baby, a new
bush, a tiger, and a tredmil

It's the thought that counts.

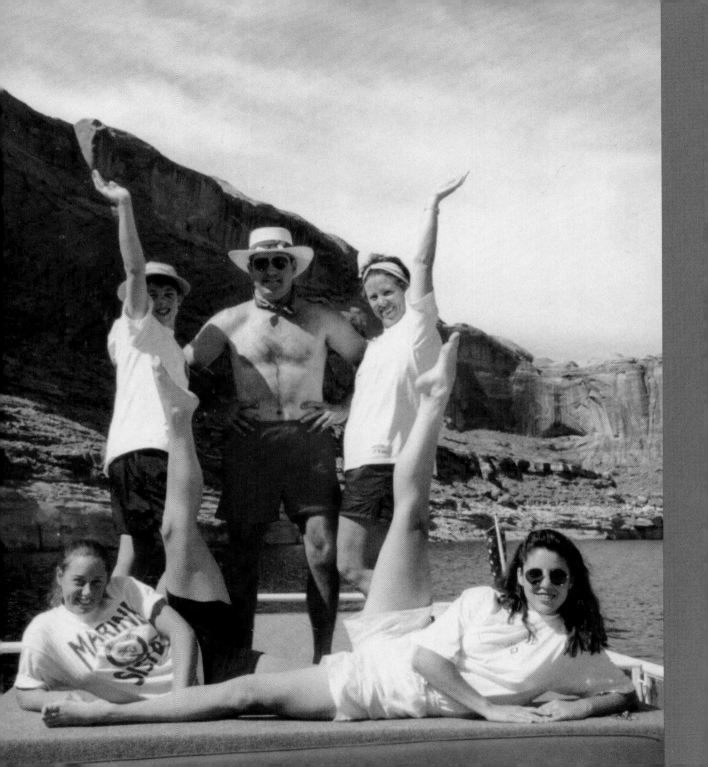

4

Father's Day

Father's Day is a time to honor the man of the house who never gets enough credit for his Hawaiian shirts, for his attempts to fix the leaking sink, and for overcooking meat on the barbecue. But Dad finally gets his due on Father's Day, and out of guilt for taking him for granted, we give him a free pass. Not burdened with parental responsibilities, we allow Dad the freedom to go topless (and sometimes bottomless), take a few extra minutes on the can, and prove to the family that time hasn't affected his athletic ability, his alcohol tolerance, or his video game skills. As his holiday winds down, Dad seemingly regresses into an irresponsible sixteen-year-old, and we count down the hours until we can underappreciate him again.

The kind of validation every father is looking for.

IN GOOD HANDS

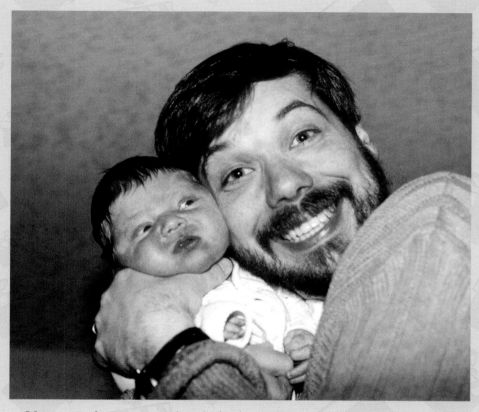

You can always spot the dad who will have trouble letting go.

HOSED

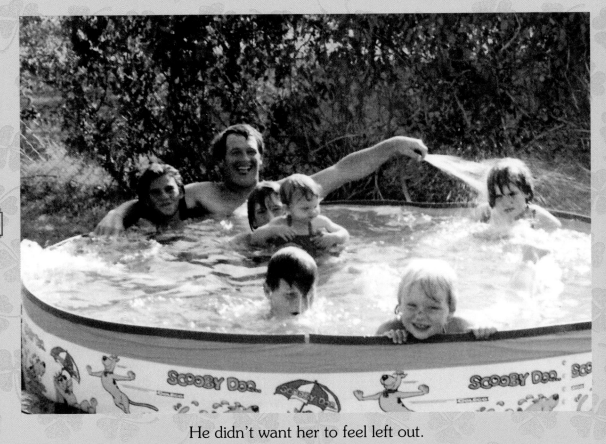

He didn't want her to feel left out.

APPLE OF HIS EYE

It's comforting to know that no matter how busy Dad is, we are always his number one priority.

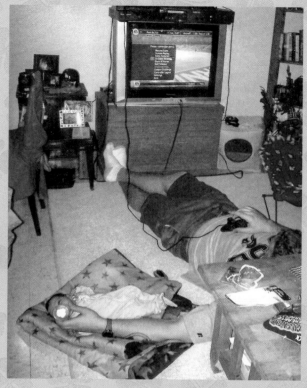

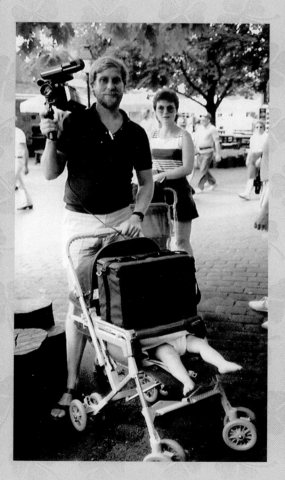

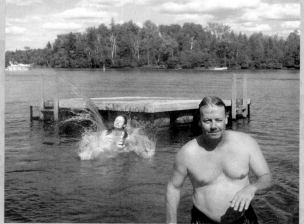

TOILET PAPER

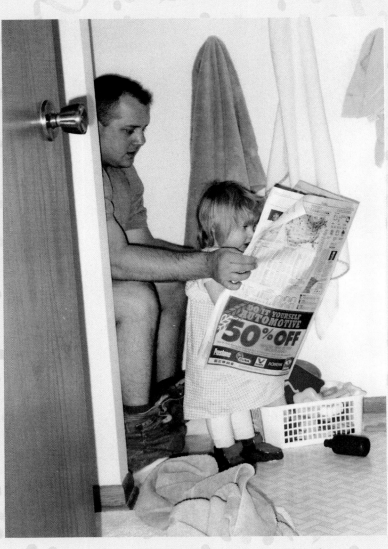

He wants to include us in everything he does.

HAZED

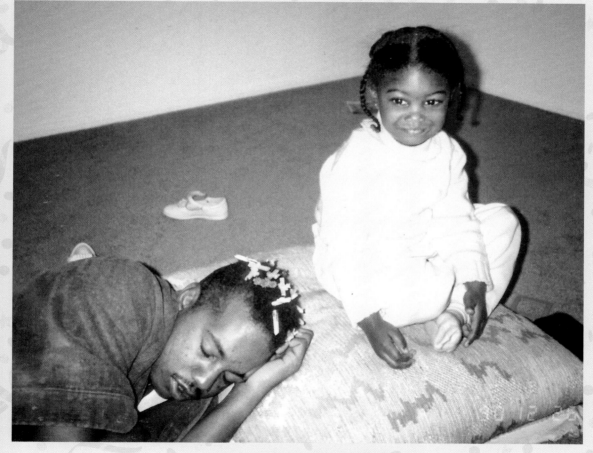

Never fall asleep on the job.

HAIR OF THE FAMILY

Only Dad can pull off the headstache.

SOMEONE TO WATCH OVER US

Some dads take being the "head of the family" too literally.

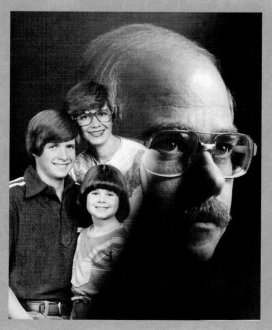

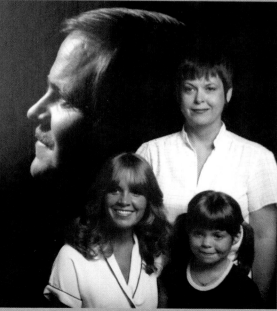

THE APPRENTICE

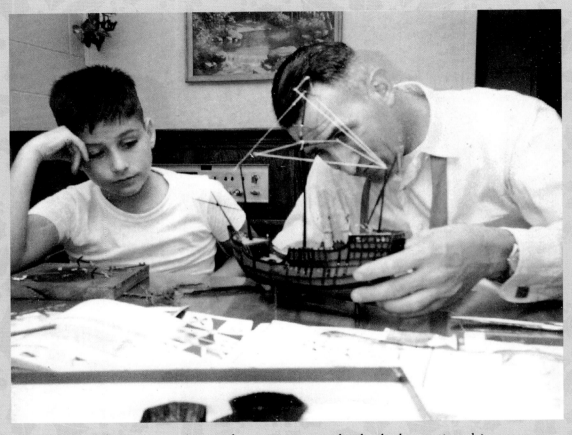

His father gave him a few pointers as he built the entire ship.

SCENIC

He just wanted everyone to know how sharp he looked.

MANSCAPING

Nobody loves yard work more than Pops, and let's face it—nobody looks quite as good doing it.

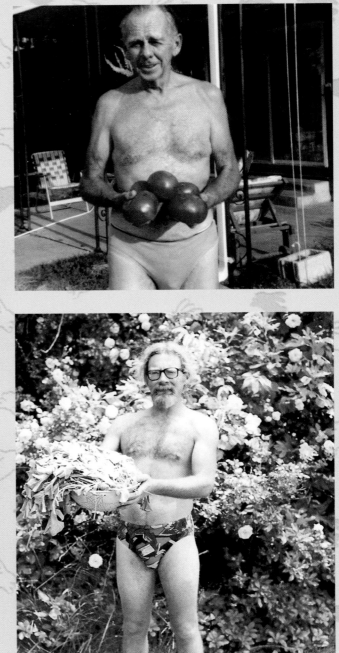

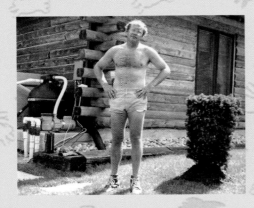

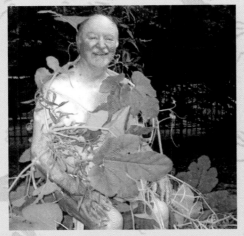

SEPTICPHOBIA

He never thought he would miss the plunger.

LIKE FATHER . . .

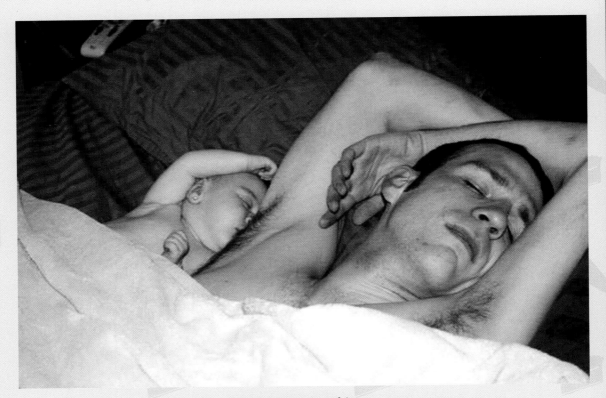

She was the apple of his armpit.

PLEASE BE SEATED

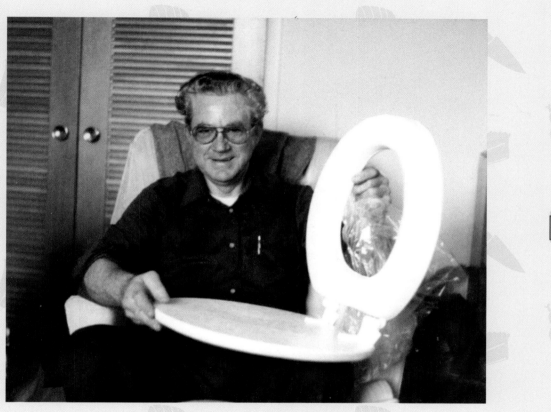

Every king needs a throne.

THE GREAT BAMBINIS

We are his pride and joy, and Dad has his own unique way of expressing his jubilance (no babies were harmed in the making of these photos).

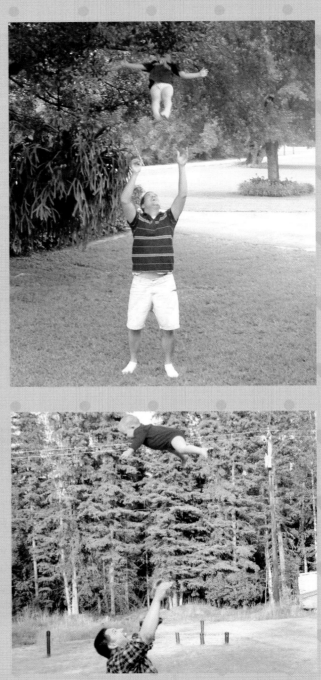

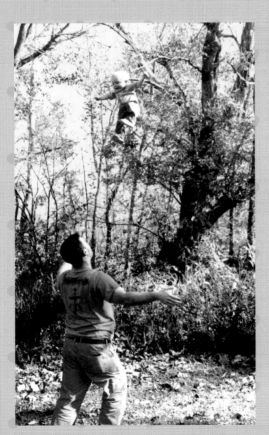

SUCH GREAT HEIGHTS

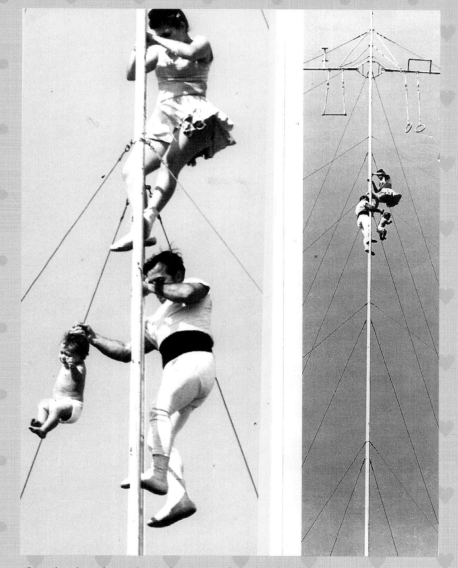

On the bright side, what's under the bed doesn't seem so scary anymore.

R & R

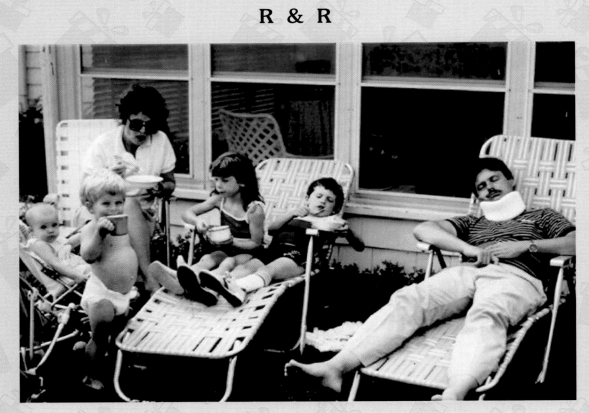

Sometimes, he needs a break.

SILVER SPOONS

His dad can hire someone to beat up your dad.

SIPPY CUP

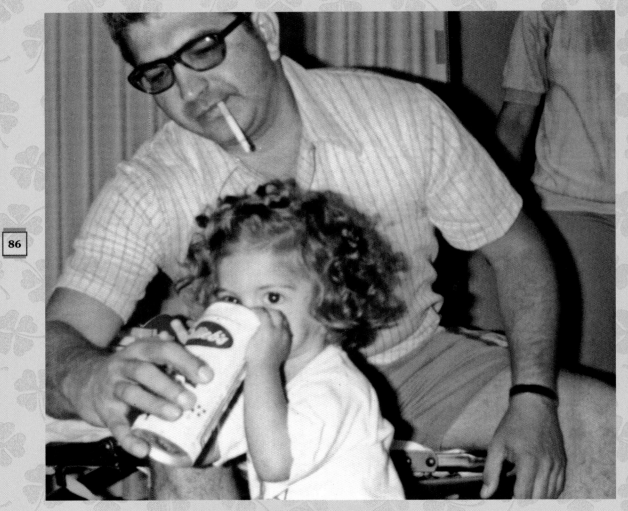

Dear Dad, thank you for being our role model . . .

LIGHT READING

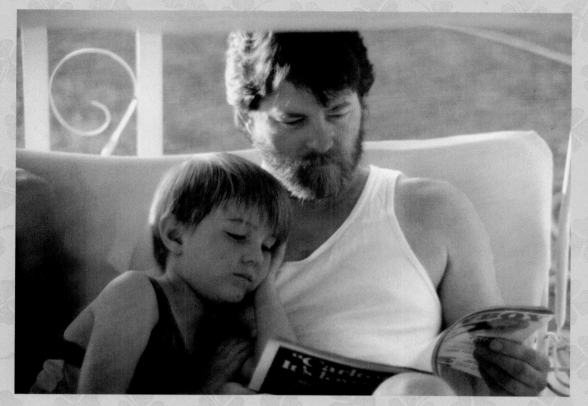

. . . and our greatest teacher (yes, that's a *Playboy*).

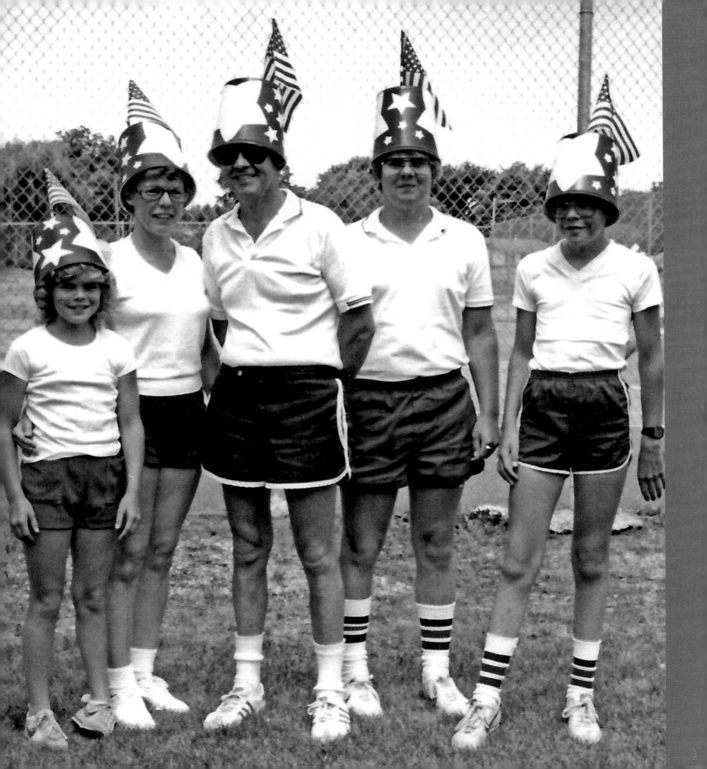

5

Independence Day

While some of us commemorate the Fourth of July by simply watching the fireworks on television, the patriots of the family insist Independence Day deserves a far more elaborate celebration. So, we display the Stars and Stripes across the front door, we dress in flag-inspired fashion, and we attend the traditional holiday barbecue where cakes are topped with American-flag frosting so that we can actually taste the freedom. It may all seem a little over-the-top, but then again, it's hard to be subtle when the nightcap during this holiday is literally bombs bursting in the air. And after the festivities wind down, we head home realizing one truth to be self-evident: even though our country may be free, we'll never be free from our own awkward families.

LIBERTY FOR ALL

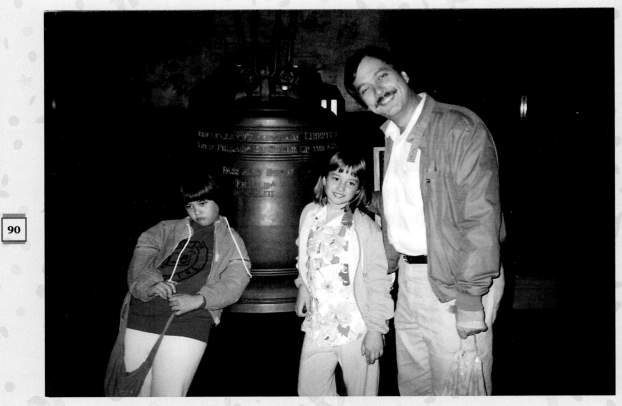

We have the freedom to be miserable.

THE PATRIOTS

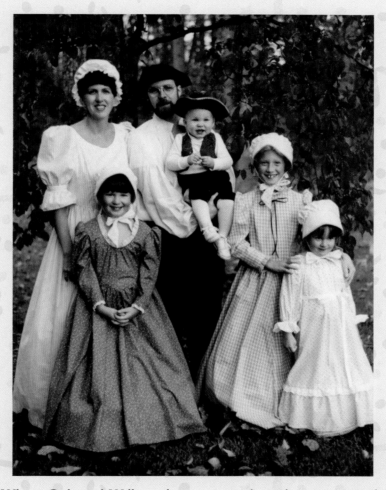

When Colonial Williamsburg just isn't authentic enough.

COOKOUT

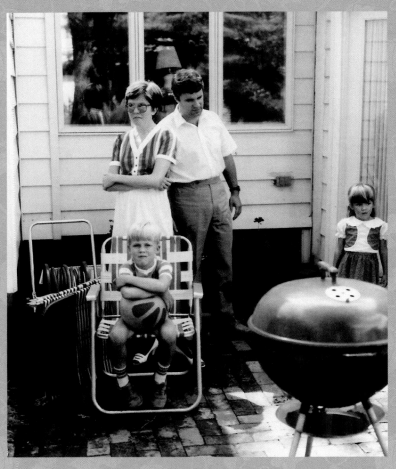

The fireworks had started earlier than usual.

UP IN SMOKE

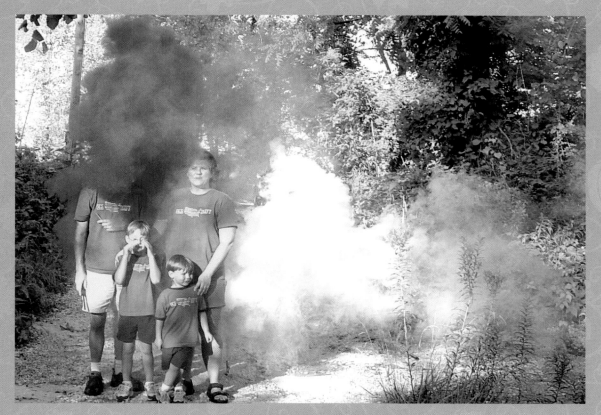

The good old magenta, gray, and blue.

I PLEDGE ALLEGIANCE

There is no greater symbol of patriotism than our flag, and as these true Americans prove, you can never be too patriotic.

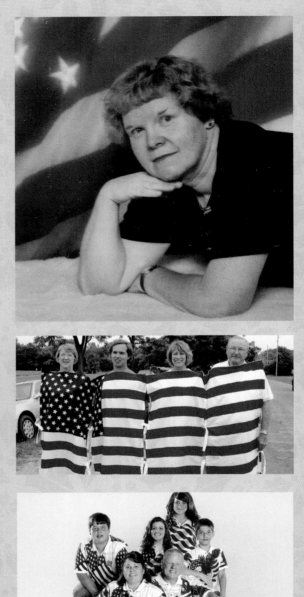

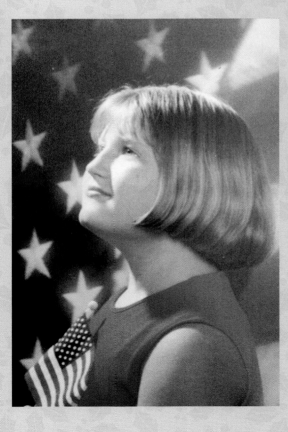

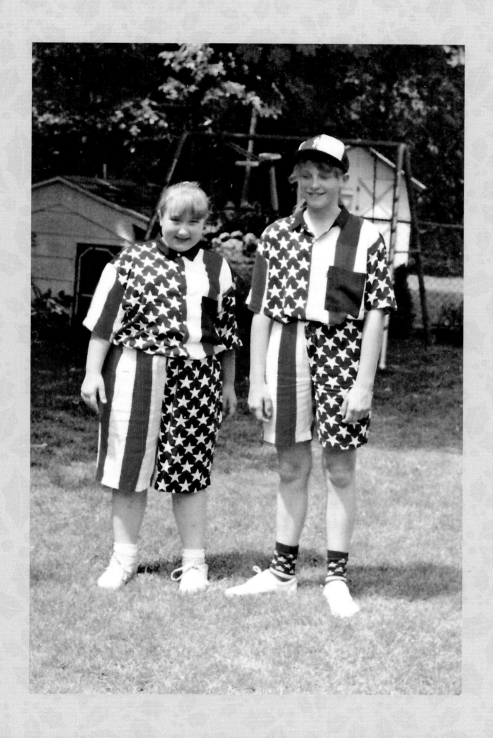

NATIONAL PRIDE

Patriotism is subjective.

SPARKLE

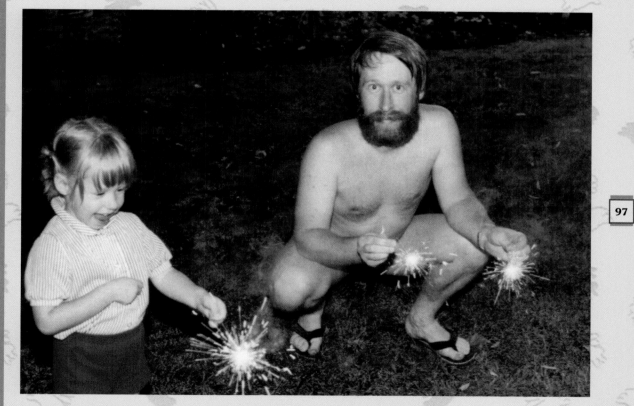

He wore flip-flops for protection.

Some of us are born stars.

BEHIND THE AWKWARDNESS

This photo was taken by my dad on July 4, 1976, standing in front of our beloved camper in Sequoia National Park. It was my aunt's idea to get the shirts, which were actually a spontaneous gas station purchase. As you can see, everyone was a little annoyed, and as soon as the photo was done, so were the shirts.

Chris
Los Angeles, California

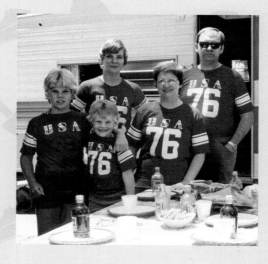

My grandmother owns a store in the town I grew up in, and every year she enters a float into the July 4 parade. Of course, this meant that I had to be on every one, usually in some ridiculous costume. I think that this was by far the most embarrassing year, though. I'm the waving cherry on the far right, and my cousin, on the far left, took the smarter approach and didn't show his face for the entire parade.

Treg
Austin, Texas

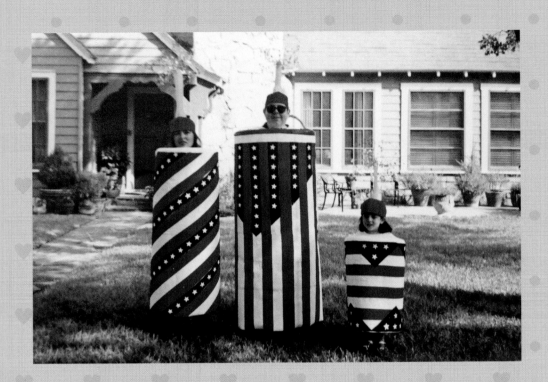

This is a pic of me and my parents
on the Fourth of July. Every year, our
neighborhood has a parade, and this year
in particular, my dad went all out, making
us wear these awful costumes. I was very
upset because all of my friends got to ride
their bikes in the parade and I had to wear
the costume with my parents. My dad still
considers these outfits a success because
they got us a photo in the newspaper.

Jamie
San Antonio, Texas

MR. U.S.A.

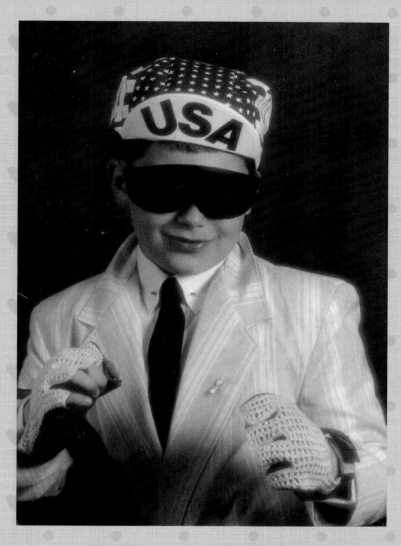

Here's what we know for sure: he's sensitive to light, he benches, and he's on the verge of flipping up his collar at all times.

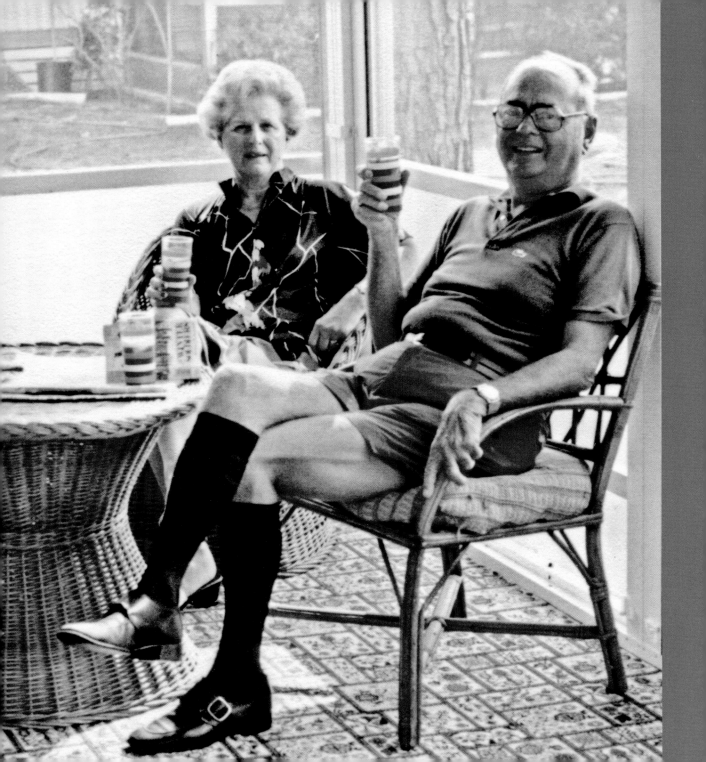

6

Grandparents' Day

Our grandparents shower us with gifts and sweets, and tell us how great we are (even if there's plenty of evidence to the contrary), so it's only fair that we return the favor once a year. And even though they sometimes get a bad rap for their daily routines of watching *Judge Judy* and playing card games, on Grandparents' Day, we honor the wisest members of the family. They're the only ones who can pull off daring fashion choices like dress socks with short shorts. They have a unique ability to nap in noisy restaurants and crowded stadiums. They provide us with old-school advice like it's perfectly okay to take an "eye for an eye." And after we climb into their boat-sized Buick, join them for an early bird special, and say good-bye, it's nice to know that we still have half the day to do whatever we want.

QUILTIES

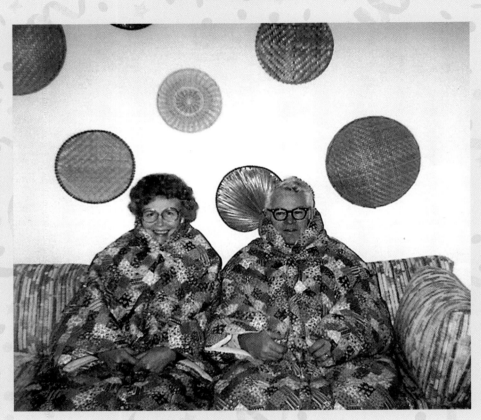

An early prototype of the Snuggie.

HOW NANA GOT HER GROOVE BACK

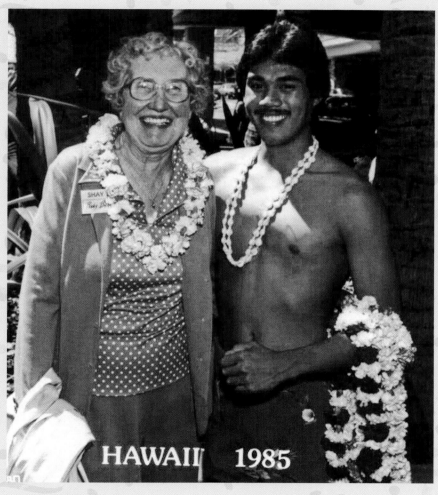

HAWAII 1985

It had been a long time since Grandma had been "lei'd."

BIG

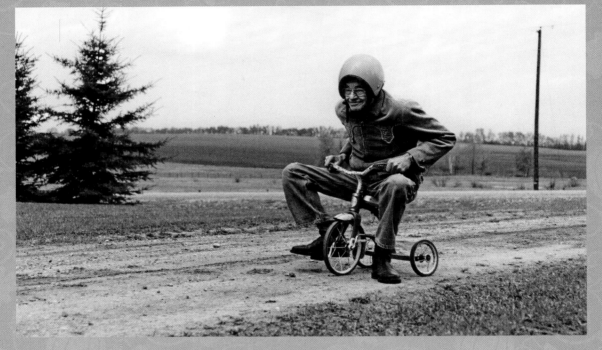

You're never too old to be awkward.

SWEETIE

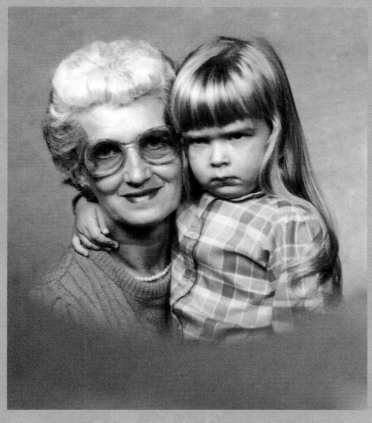

She always looked forward to spending time with Grandma.

WHAT ABOUT GRANDMA?

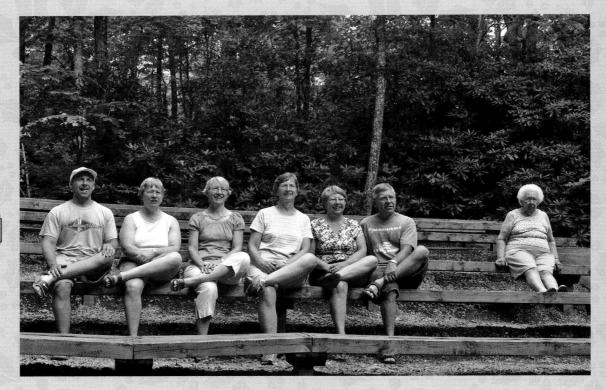

Left out, but never forgotten.

HARD TO HANDLE

The true pleasure of grandparenthood is knowing that, at the end of the day, the kids go home.

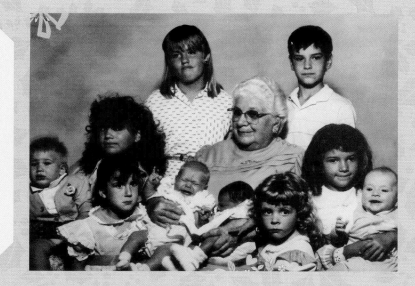

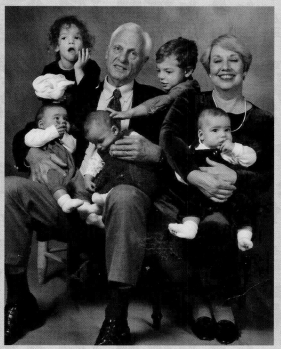

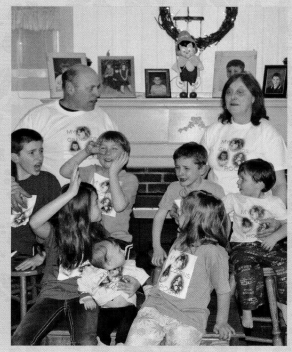

WIPEOUT

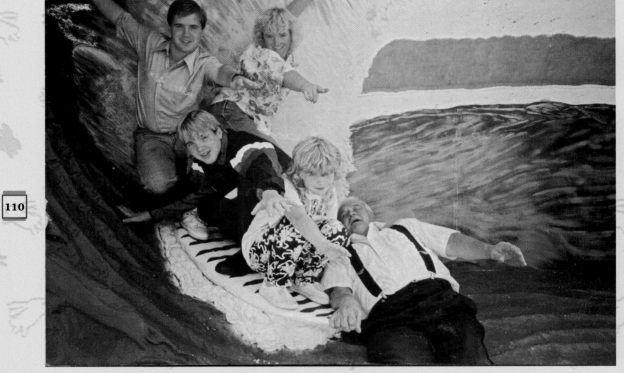

Correction. Wiped out.

JARHEADS

They were lured in by hard candies.

MIRACLE WIPE

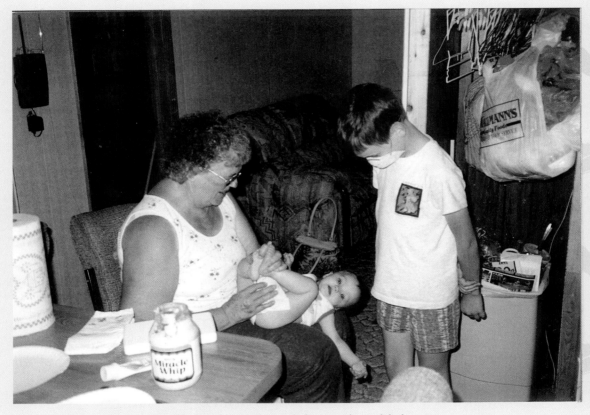

That's how they did it in the old days.

ON THEIR WATCH

Our kids are our everything, so when we turn them over to Grandma and Grandpa, it's nice to know they're in good hands.

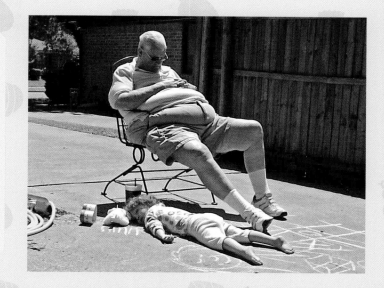

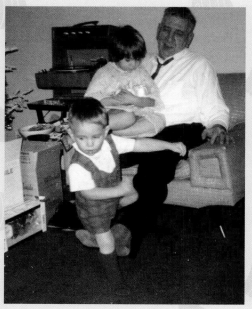

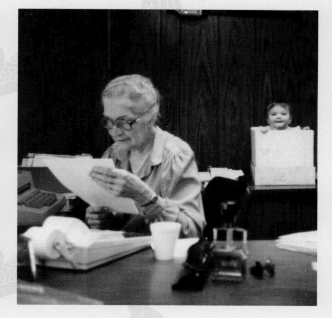

GRANNY GET YOUR GUN

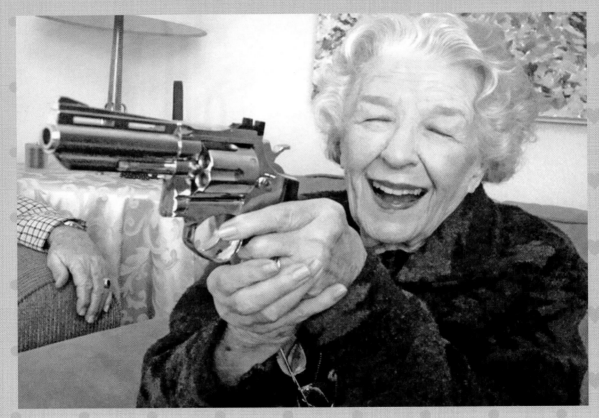

Finally, something she didn't need her glasses for.

EARLY BIRD SPECIAL

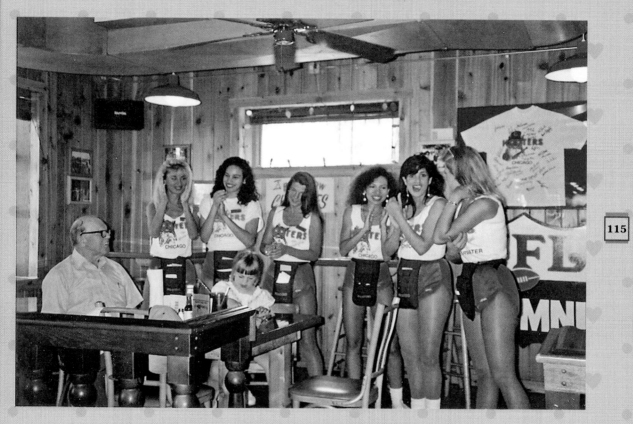

It's an unselfish love.

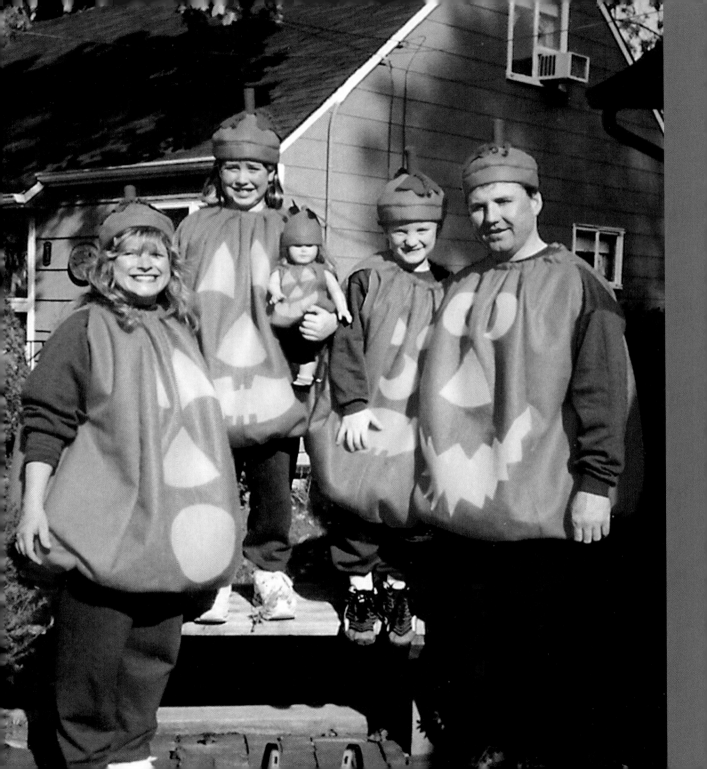

7

Halloween

Halloween is one of the most anticipated holidays of childhood. We spend months picturing ourselves dressed in awesome costumes, like a superhero, a cowgirl, or an intergalactic bounty hunter. We imagine walking the streets with friends, happily knocking on our neighbors' doors and filling our jack-o'-lantern baskets with delicious, sugar-filled candies. But when the big night finally arrives, our dreams of elaborate costumes are squashed by Mom's sudden interest in arts and crafts. So, we end up dressed as strange combinations of cardboard boxes, hastily sewn sacks of miscellaneous fabric, and lumpy papier-mâché. Instead of spending the night with our friends, we're chaperoned by Mom and Dad, which makes us wish our masks could hide even more of our faces. And after we cross paths with the older kids in the neighborhood or our elder siblings who take our hard-earned candy as if it were a rite of passage, it sure feels like the holiday slogan was false advertising, because to us, Halloween just seems like one big trick.

MASK

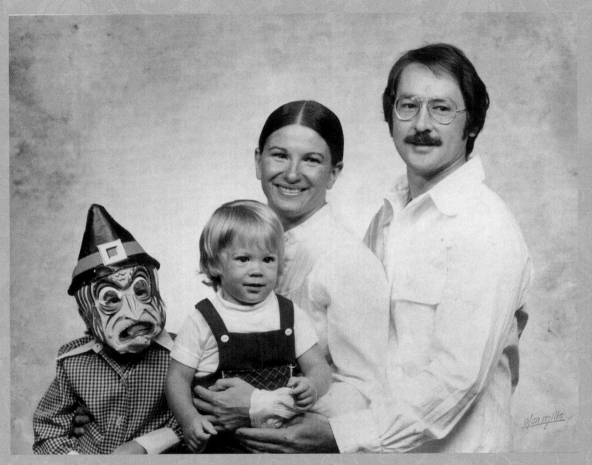

Halloween is a state of mind.

MR. MOM

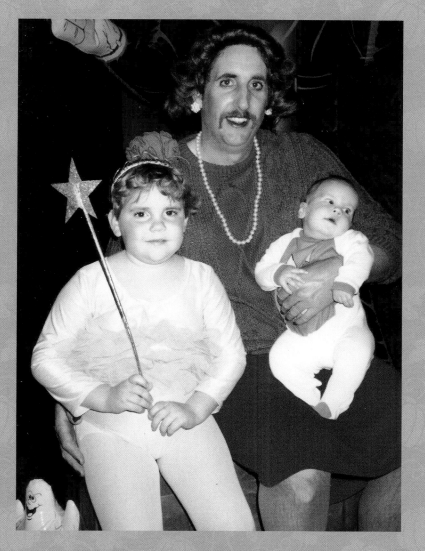

Who said dressing up is just for the kids?

BABY ALIVE

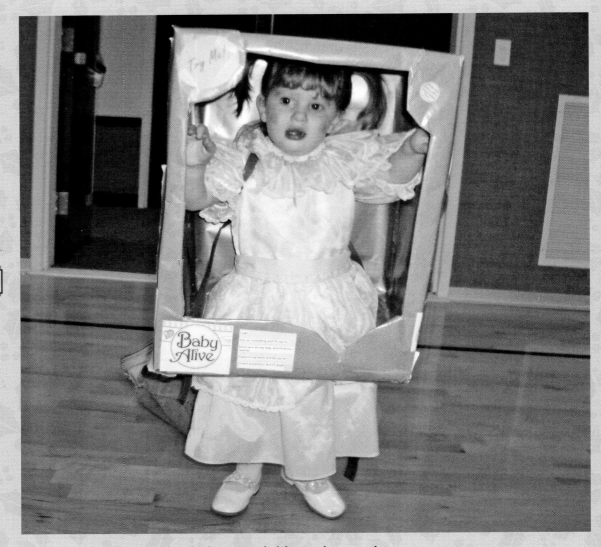

A reminder to let our children choose their own costumes.

PUMPKIN PIE

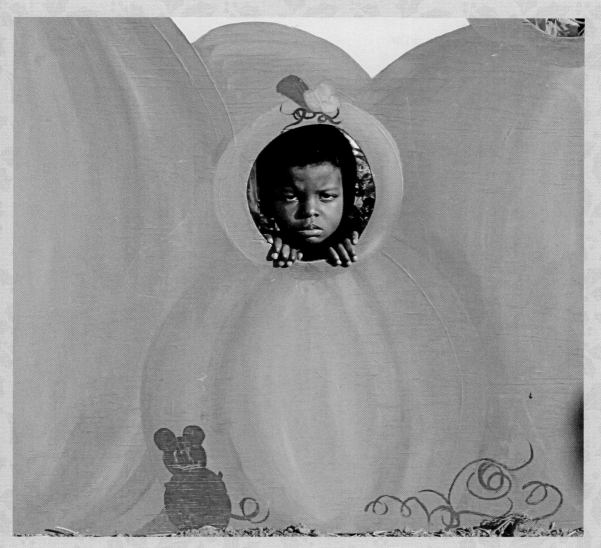

The holiday spirit was not contagious after all.

MISS PIGGY

She didn't share her mom's passion for anatomical realism.

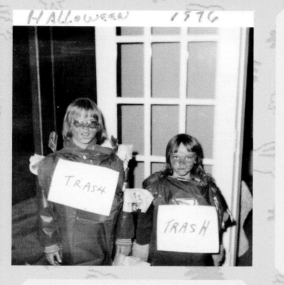

HALLOWEEN 1976

TRASH

TRASH

BEHIND THE AWKWARDNESS

Mom decided to save money on costumes that "you only wear once." So, she tied trash bags to my brother and me and stuffed them with newspaper, smeared brown eye shadow on our faces, and pasted big signs on our chests that said TRASH.

Michelle
McCordsville, Indiana

My loving mother (the one on the sled) thought it would be wonderful if we all wore our ballerina pig costumes that she had hand-made for us. My sister, Adellie (in front), and I were firmly instructed to look as though we were having a jolly good time as we pretended to push our mommy through the snow. I recall crying a lot during this photo shoot. And the answer is yes, we were forced to wear these on Halloween, and yes, it was on our Christmas card that year.

Ava
Kalamazoo, Michigan

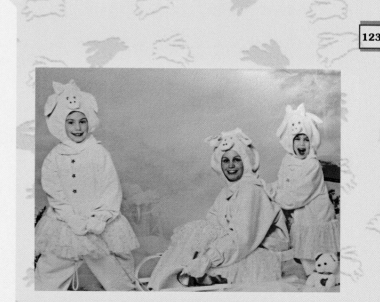

This was taken around 1981–82, and I'm posing with a monster at a local haunted house. I was addicted to horror movies as a kid (and still am), so whenever the haunted house started up, I'd beg the lady at the door to go inside with the lights off. (They kept the lights on for a few hours during the day for little kids.) After an endless amount of badgering, she finally let me go through in the dark. Expecting me to run back out screaming, she stood by the entrance—only to see me come bouncing through the exit with a huge smile on my face. To commemorate this, she let me pose for a picture with the demon.

Lonnie
Springfield, Ilinois

Me during my first Halloween, bearing a striking resemblance to the plastic jack-o'-lantern.

Veronica
Studio City, California

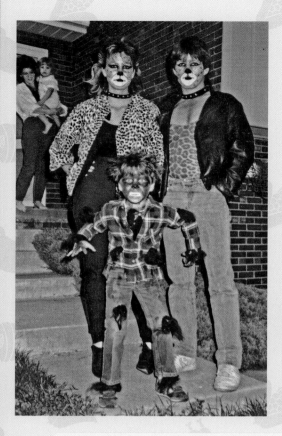

It's hard to look scary as a werewolf when your parents look like they're starring in the musical *Cats*.

Robbie
Lexington, Kentucky

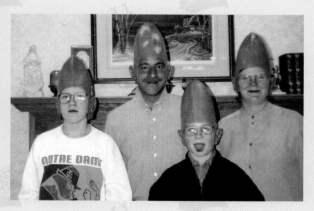

Yes, this is my family. I am the smallest Conehead. In a brilliant wave of genius, my mother thought she had discovered the ultimate family Halloween costume when she found these smelly rubber cone heads at some long-forgotten costume shop. We were all a little uncomfortable with the idea, but with only a few short days until the yearly Halloween party, we decided to go for it. So, we went to the party, and after a few dull roars from the crowd, this bougie family swooped in to steal our thunder dressed as the ENTIRE cast of *The NeverEnding Story* . . . yep . . . even Falkor.

Maggie
Amherst, Massachusetts

It was Halloween 1985—my older sister's last year for dressing up. Halloween was my dad's favorite holiday, and he always wanted us to be the Three Bears. The only thing is that we figured he would want to be Papa Bear!

Ellie
Millsboro, Delaware

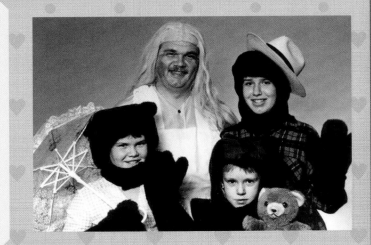

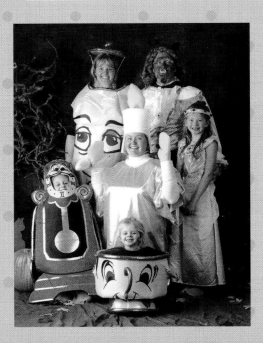

When I was younger, my family and I would have themed Halloween costumes. This year was *Beauty and the Beast*. My aunt's Lumière costume was a crowd favorite, of course, and my older sister was forced to be Cogsworth just for the photo. The photo also features myself as Belle, my little sister as Chip, my mother as Mrs. Potts, and my dad as the Beast. It's an odd picture but one of my favorites from my childhood.

Grace
Clarkston, Michigan

PREGAME

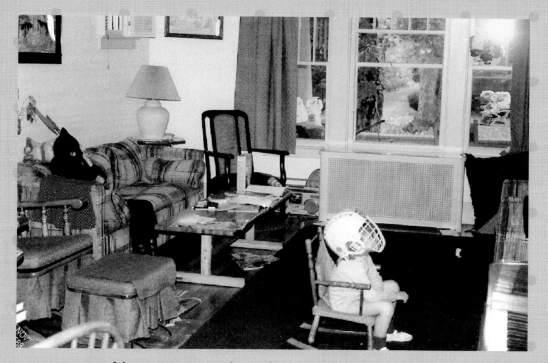

It's never too early to throw on your costume.

HAPPILY EVER AFTER

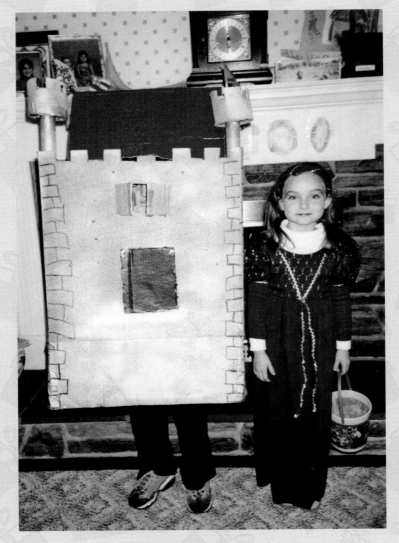

The castle was better in theory.

THERE'S NO PLACE LIKE HOMEMADE

Our parents try to convince us that store-bought costumes are a dime a dozen and unimaginative, but they don't have to go to school the next day.

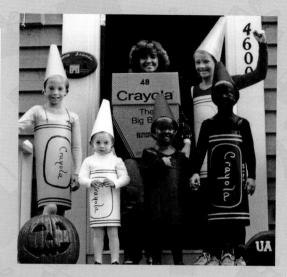

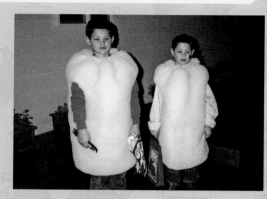

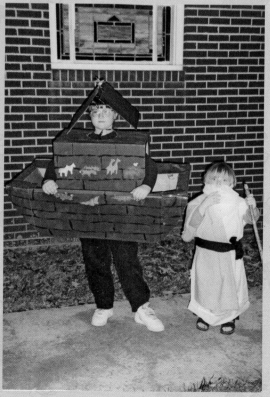

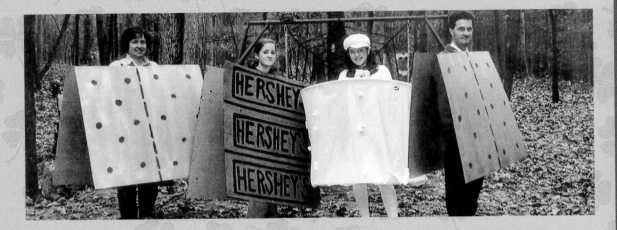

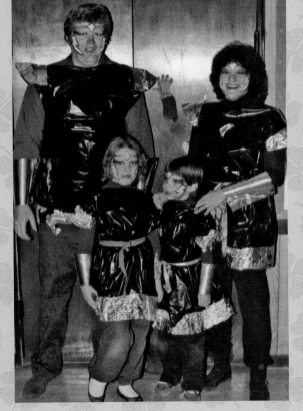

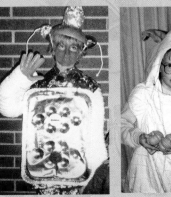

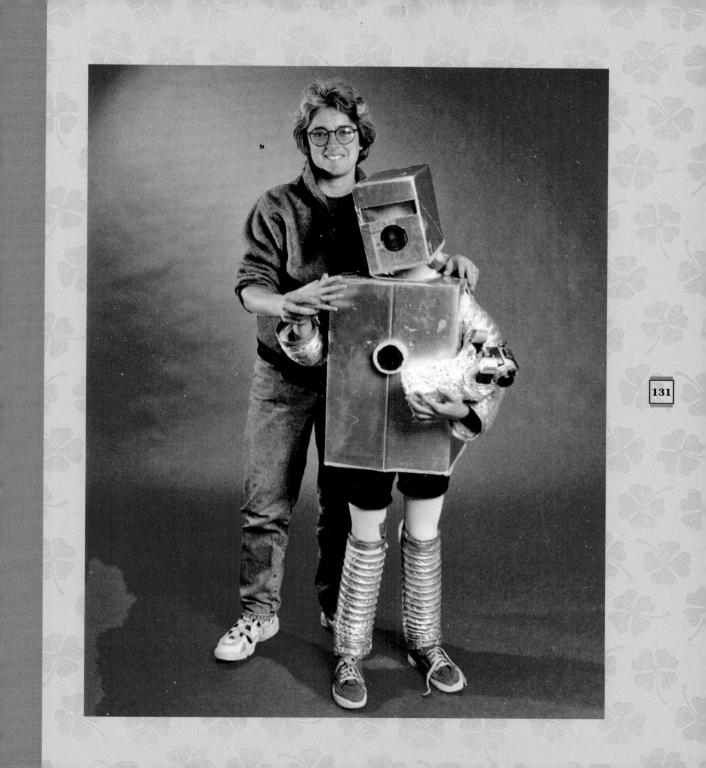

READ MY LIPS

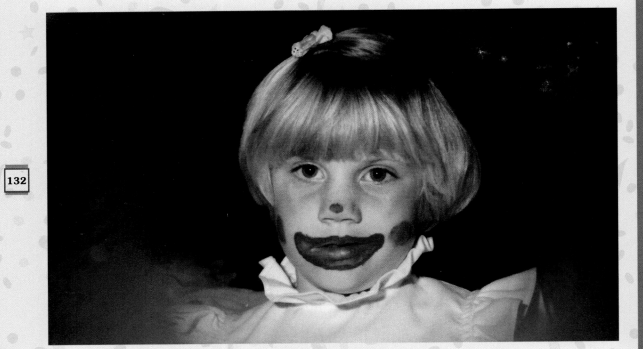

She does her own makeup.

ELEPHANT IN THE ROOM

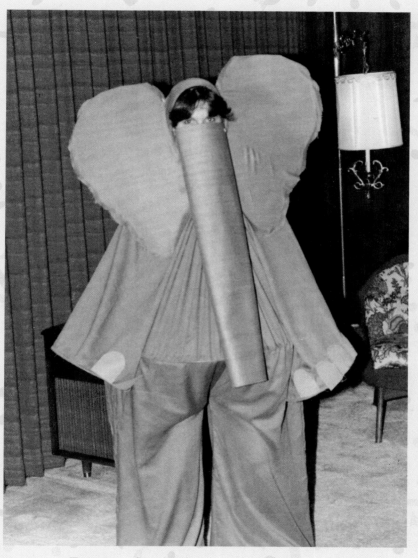

Fortunately, she has a human memory.

Next year, they are thinking of growing more than one pumpkin.

THE WAITING GAME

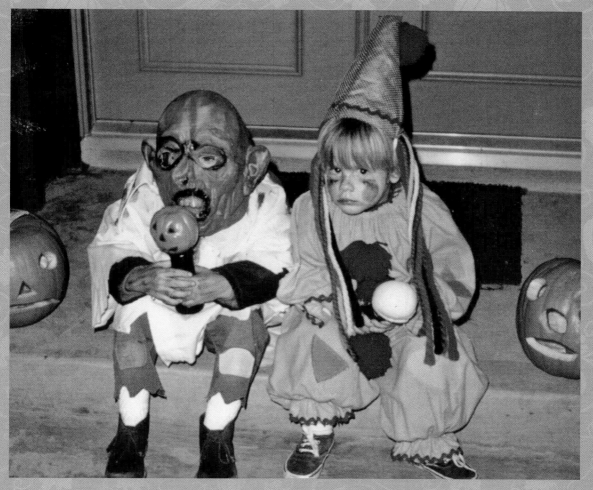

Sometimes, it feels a lot more like a trick.

THE COUNT

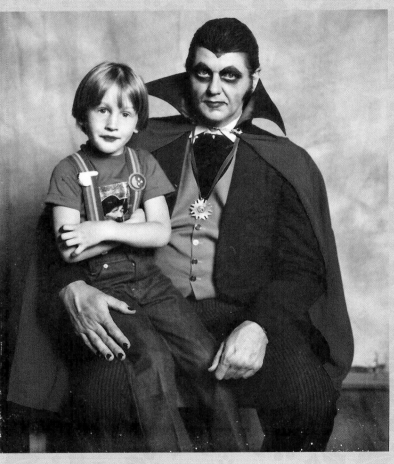

Scary is in the eye of the beholder.

CLOWNING AROUND

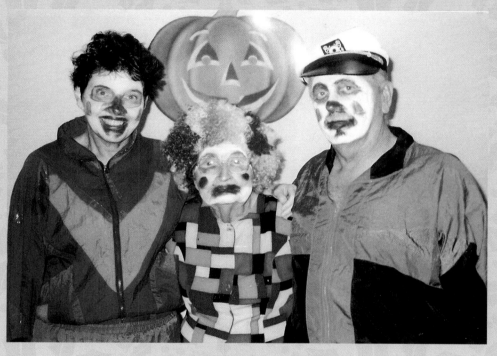

You're never too old to freak everyone out.

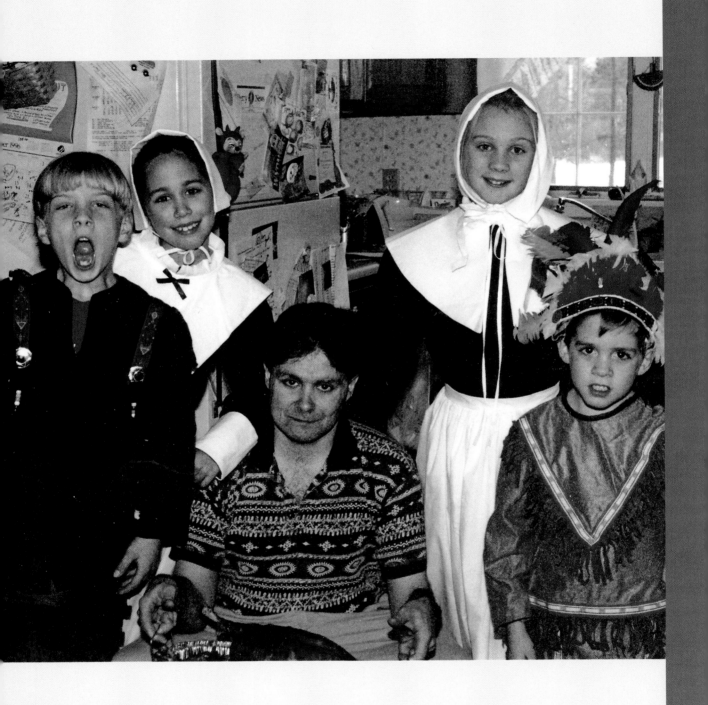

8

Thanksgiving

Thanksgiving may teach us about Plymouth Rock, the Pilgrims, and the Indians, but the only thing anyone remembers about the holiday is the epic feast. And that's because this is more than just a meal; this is an event planned months in advance and attended by the whole family. When the big night finally arrives, we sit around a long table answering personal questions from aunts, uncles, and cousins we hardly know and stuff our faces with dry turkey, cement-like stuffing, and sliced cranberry still in the shape of the can it came from. Following tradition, we go around the table and describe something we're thankful for. While we're usually stumped about what to say, the rest of the family happily offers up bad jokes and alcohol-assisted revelations that make everyone uncomfortable. But as we finish the meal, it becomes obvious what we're most thankful for: that the next Thanksgiving feast is a distant 364 days away.

THE GOOD LIFE

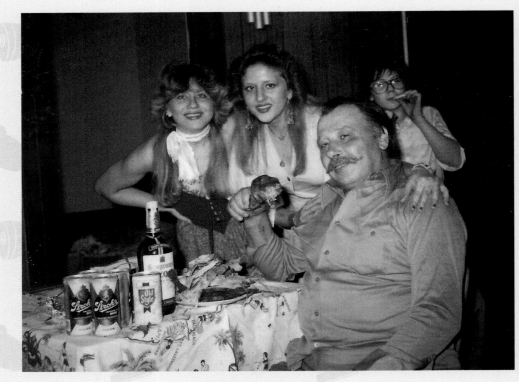

Thank you, Pilgrims.

THE VILLAGE

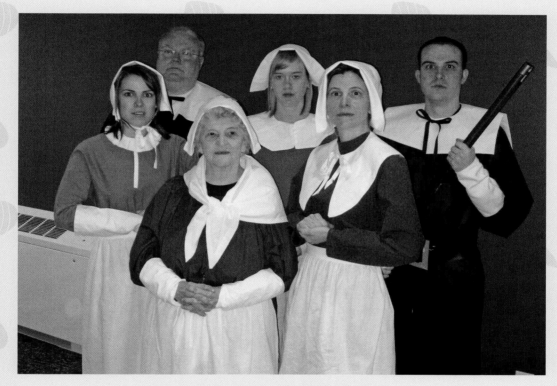

It was *almost* historically accurate.

AMAZING GRACE

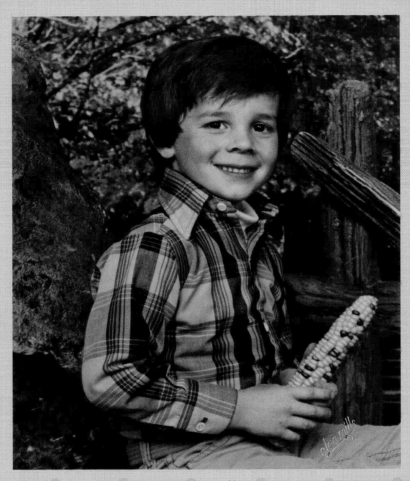

Show-off.

SCREAM

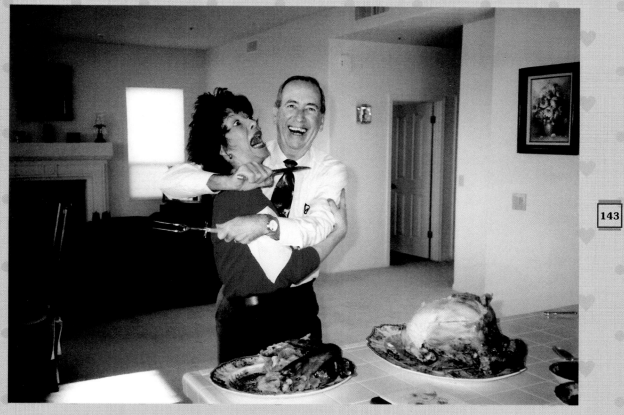

They were only half-kidding. The question is, which half?

FACE-OFF

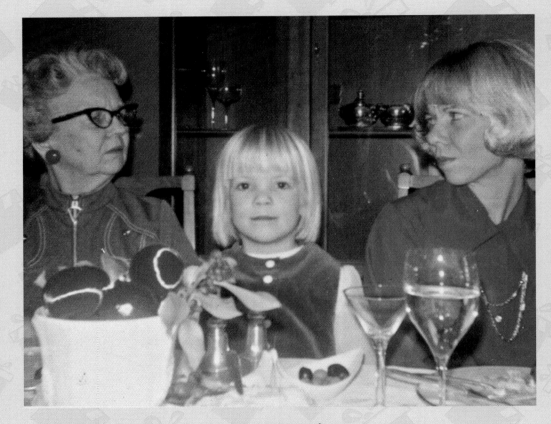

Let's just agree to disagree.

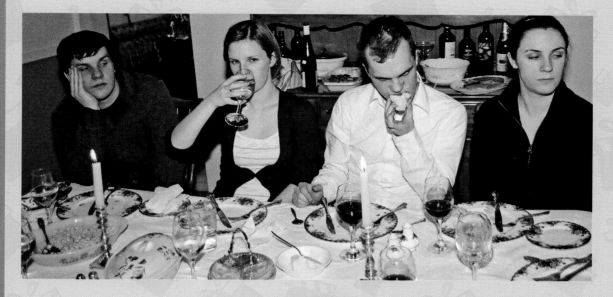

DINNER CONVERSATION

Let's give thanks that we only have to do this once a year.

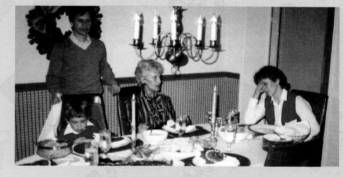

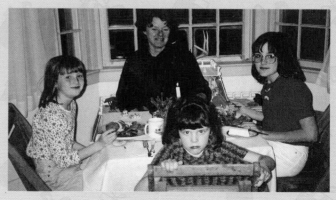

CAMERA-READY

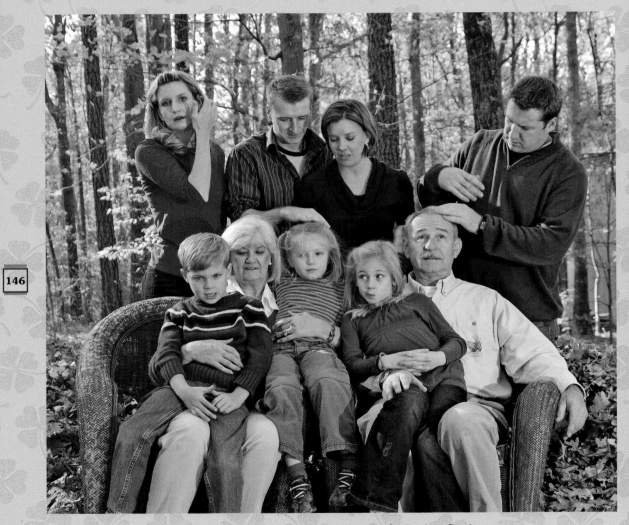

It's all about what happens before the flash.

THE ANGLER

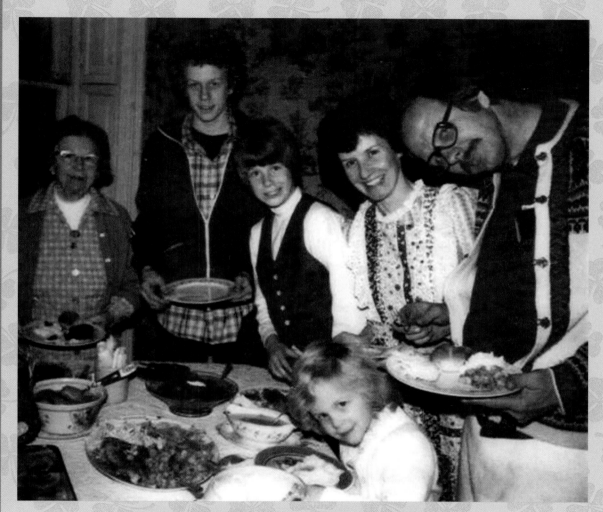

He had trouble fitting in with the rest of the family.

THE MAIN ATTRACTION

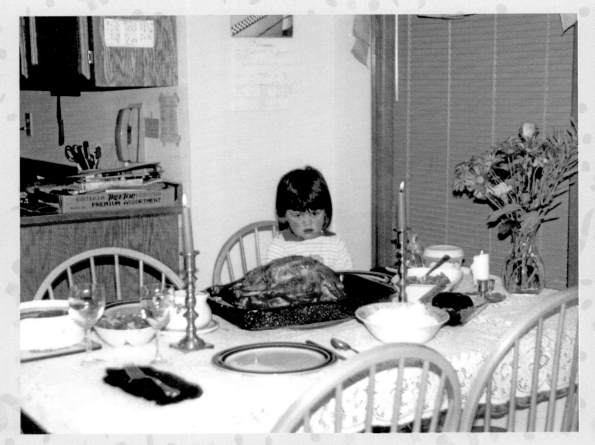

And it all goes downhill from there.

STUFFING

They're too young to sit at the kids' table, so we're forced to get creative.

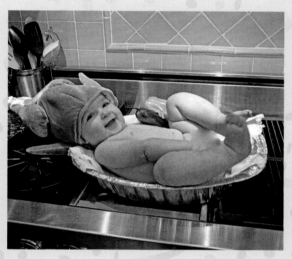

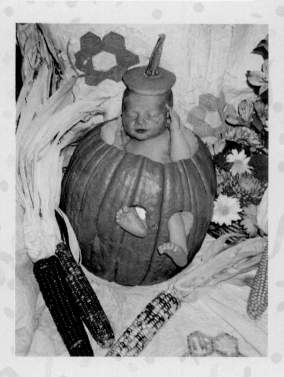

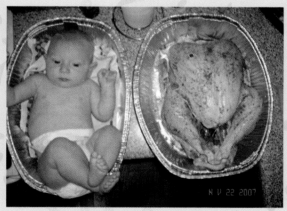

THE CRYING GAME

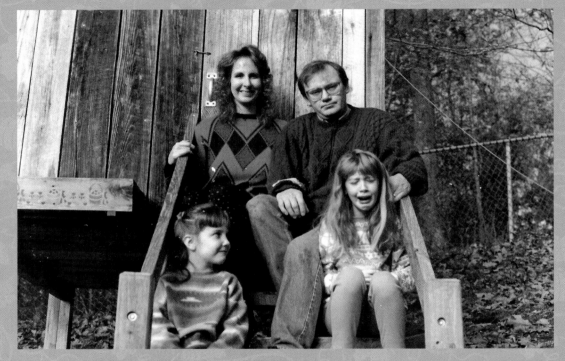

Family is always there to look out for you . . . and at you.

TRYPTOPHANIA

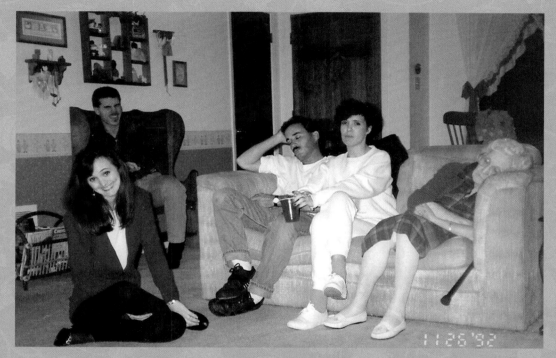

The after-dinner festivities had just begun.

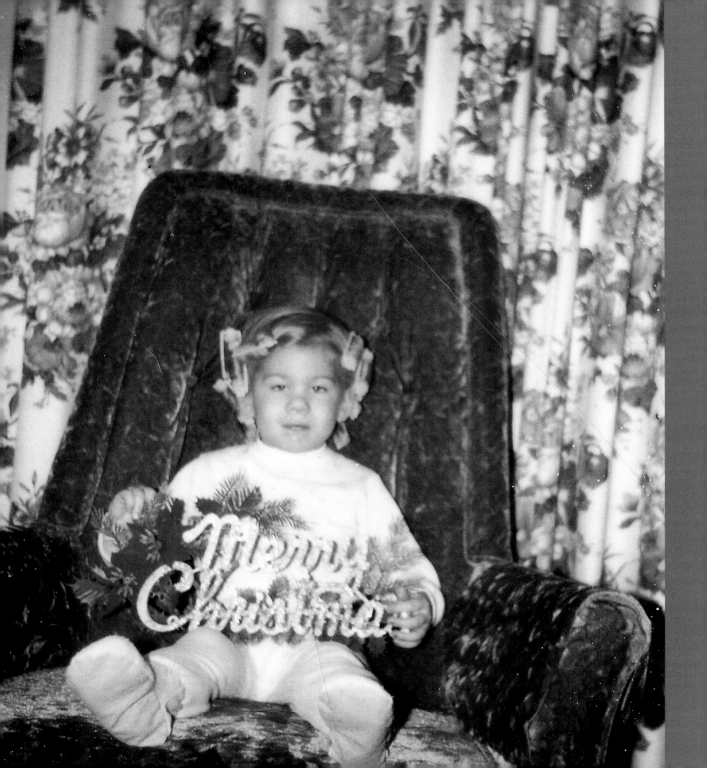

9

Christmas

Christmas is not just about presents," our parents told us over and over again, "it's about family." And they were right. It's about Mom and her compulsive need to have a picture of each of her children sitting in a bored mall Santa's lap, providing a perfect timeline of our childhoods, from terrified screaming infant to very uncomfortable middle-schooler. It's about Dad and his desire to outdo the other fathers on the block with his decorations but who lacks the skills to create anything other than a tangled ball of lights dangling from the eaves. It's about Great-Aunt Mary, who forced ugly, scratchy matching sweaters over our heads, not just for one family portrait but for the entire day. And okay, it's about the presents, which we play with excitedly for a few hours and then promptly forget about as soon as the TV is turned on. But above all, it's about a house full of relatives who all love one another, but don't always particularly like one another that much, which they do their best to hide for one day of the year . . . at least until the eggnog comes out.

THE STEAL

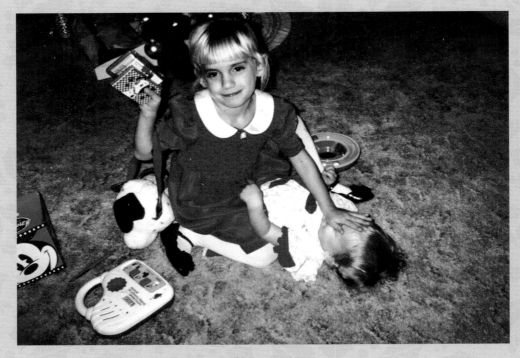

It's so much better to receive.

BELL BOTTOM

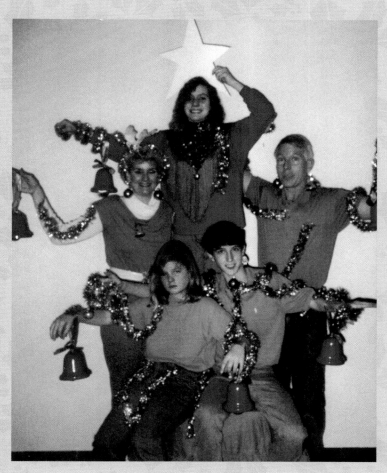

It's a long way to the top.

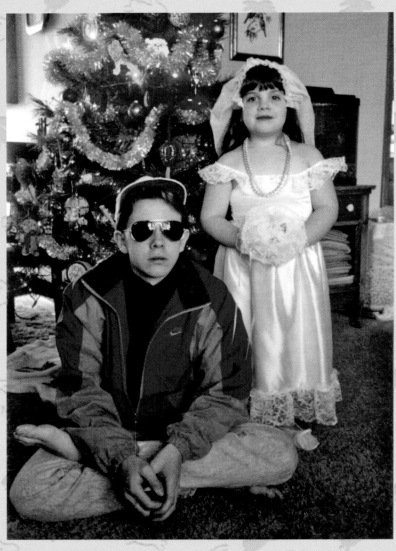

What happens at Christmas stays at Christmas.

FLASHDANCE

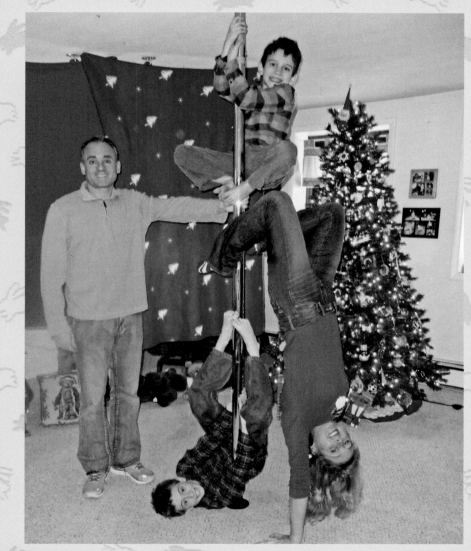

This father has to keep his whole family off the pole.

TWO FOR ONE

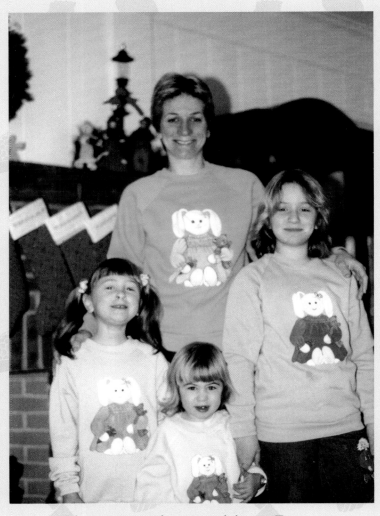

It's never too late to celebrate Easter.

HANUKKAH O HANUKKAH

It might not get as much hype as Christmas, but that doesn't mean it's any less awkward.

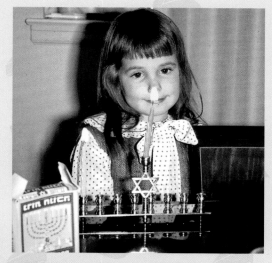

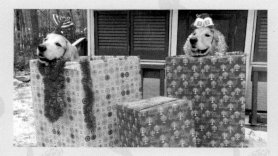

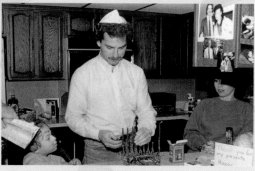

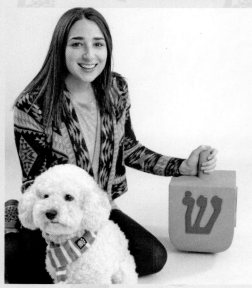

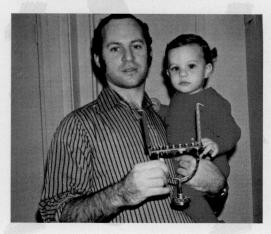

SWEATER CLUB

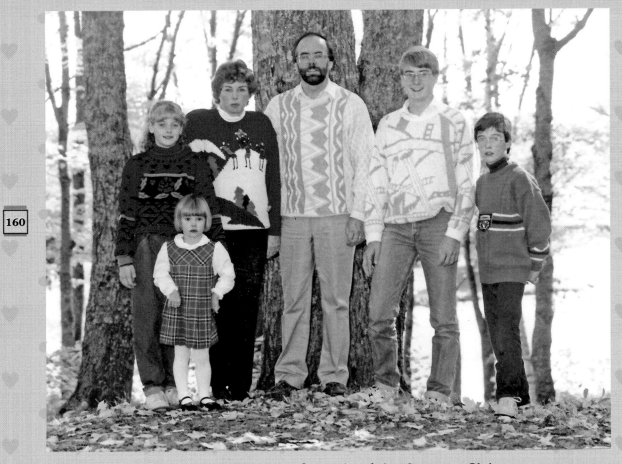

She just violated the first rule of the Sweater Club.

JOY TO THE WORLD

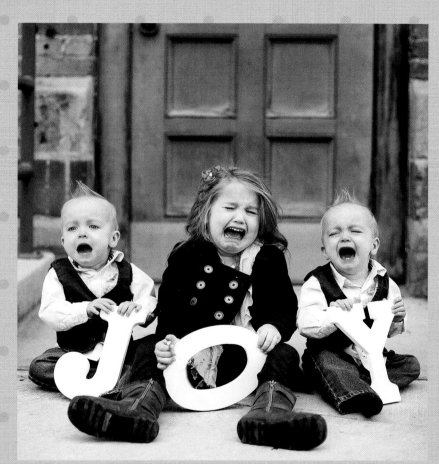

Apparently, it's infectious.

THE BIRD

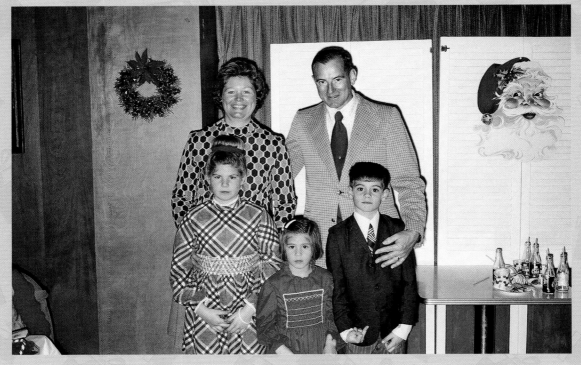

He just wanted to give props to the man who made it all possible.

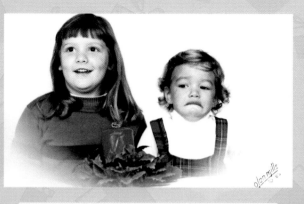

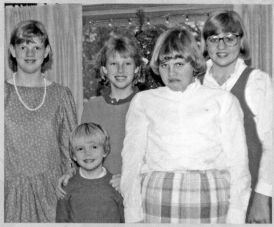

THE GRINCHES WHO STOLE CHRISTMAS

It's the most wonderful time of the year . . . for most of us.

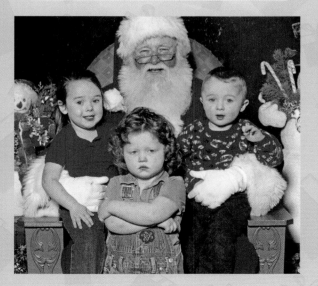

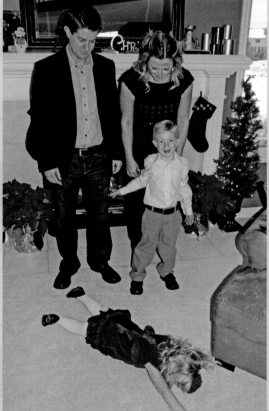

HOSTAGE

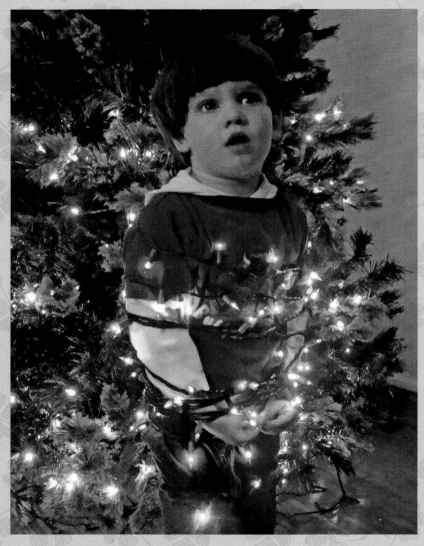

You can't escape the holidays.

SHINER

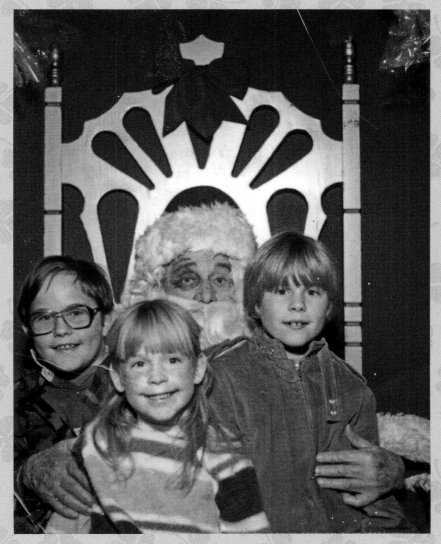

Looks like they're not the only ones who have been naughty.

BAD SANTA

They say imitation is the highest form of flattery. Well, after seeing these sketchy Santas, we beg to differ.

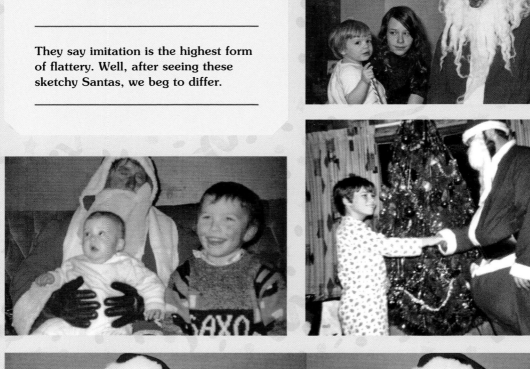

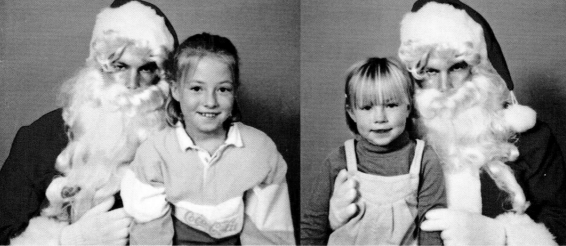

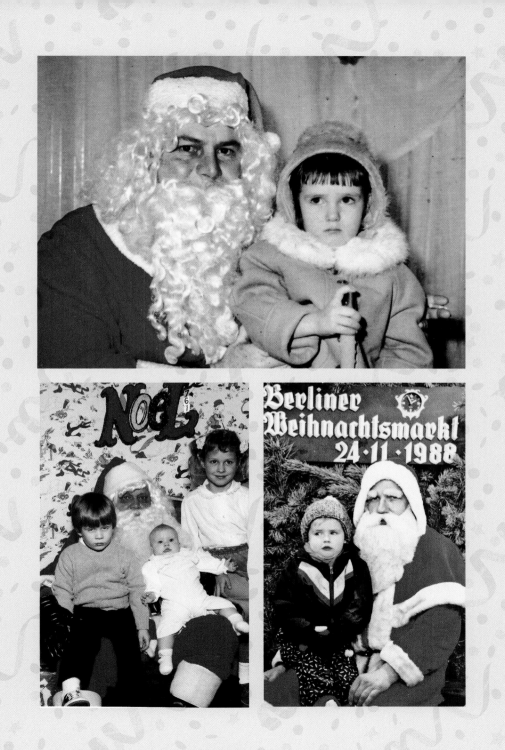

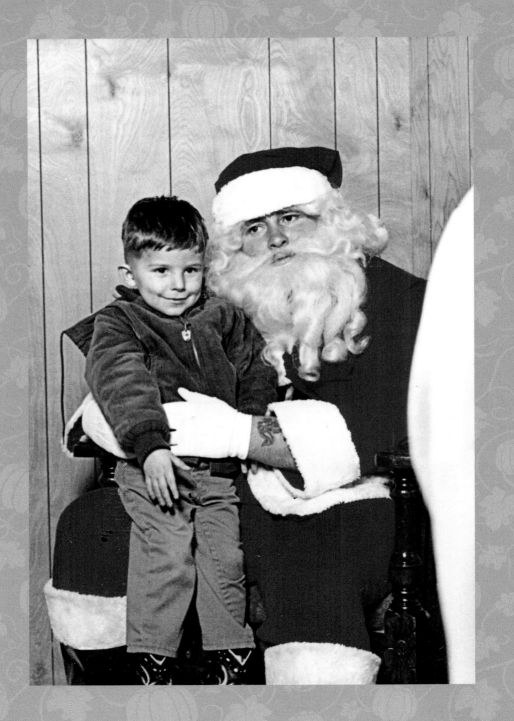

IN DEFENSE OF THE MALL SANTA

Let's face it—people think the mall Santa is awkward. And I get it, I do. We sit there in our overstuffed red robe with a glued-on beard pretending to be Father Christmas. But as a mall Santa at the White Plains Galleria in New York for many years, I'd like to offer a different point of view: it's the people who come to see Santa who are the awkward ones.

As a Santa, your job is to spread holiday cheer, but that isn't always reciprocated. I've had kids try to rip off my beard while Mom and Dad were too busy taking pictures to step in. I've been jabbed in the gut, pushed out of my chair, and had my legs practically crushed when a heavyset family decided to sit on my lap all at the same time. One supposed "child prodigy" tugged at my beard and exclaimed, "This Santa is not legit!" I've even been confronted by angry husbands who thought I was flirting with their "Ho, Ho, Ho" wives.

If this is the kind of awkward abuse that we mall Santas must endure, then so be it. For a couple of weeks a year, we get to play children's greatest hero. So, bring it on, people . . . we've got plenty of padding. Oh, and merry Christmas!

Ivan Jenson
Professional Mall Santa

HOT TUB TIME MACHINE

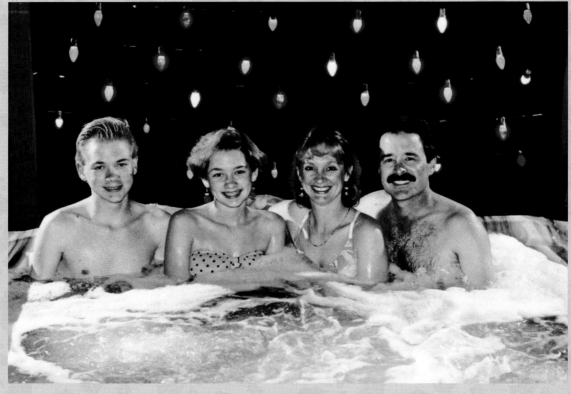

So what if the weather outside is frightful?

THE BARE NECESSITIES

Maybe it's all that decking of the halls, but there's something about the holidays that makes us want to take it all off.

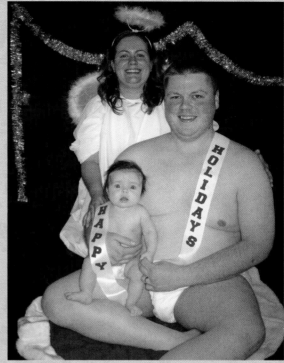

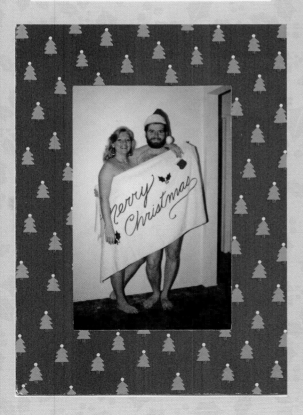

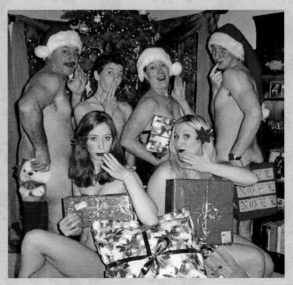

REINDEER GAMES

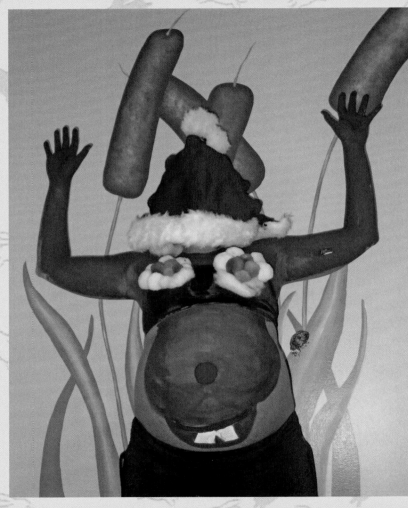

She was starting to get that pregnancy glow.

THE WISH LIST

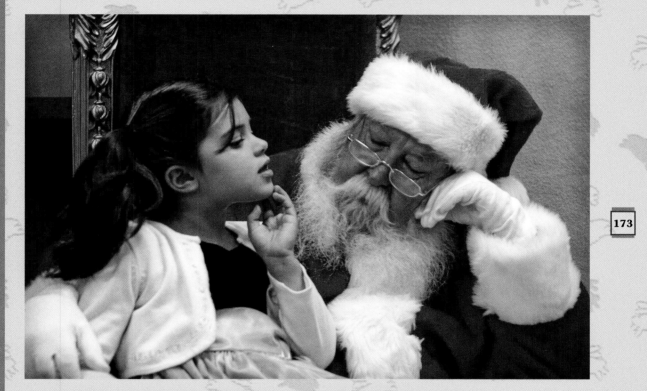

Some kids have to learn how to edit.

ELEPHANT IN THE ROOM

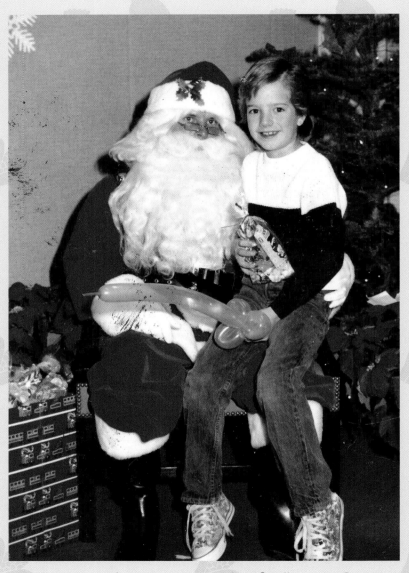

Let's just say he was overjoyed to finally meet Santa.

AN AWKWARD HOLIDAY GREETING

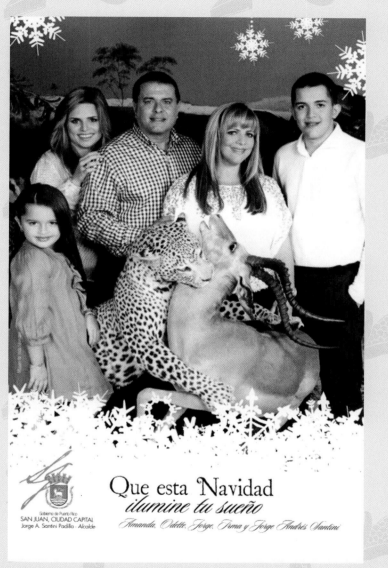

Que esta Navidad *ilumine tu sueño*

Gobierno de Puerto Rico
SAN JUAN, CIUDAD CAPITAL
Jorge A. Santini Padilla - Alcalde

Amanda, Odette, Jorge, Irma y Jorge Andrés Santini

Spreading a message of peace and joy.

SNOW-BLIND

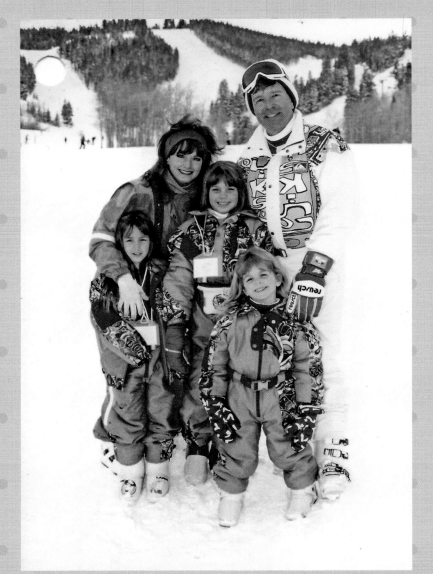

The good news is nobody got lost.

THE ABOMINABLES

As kids, we all shed a tear when our "Frosties" began to melt, but there are some snowmen and snowwomen that we wish had done so a little faster.

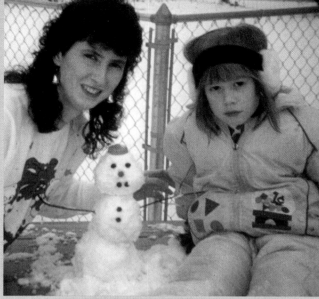

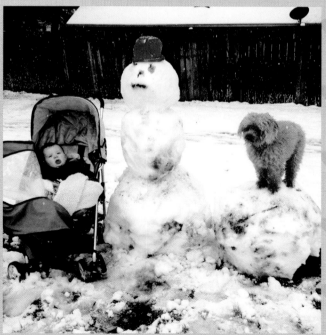

SEND IN THE CLOWN

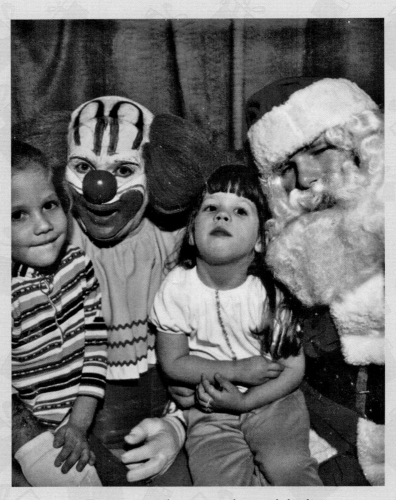

Every superhero needs a sidekick.

FURRIES

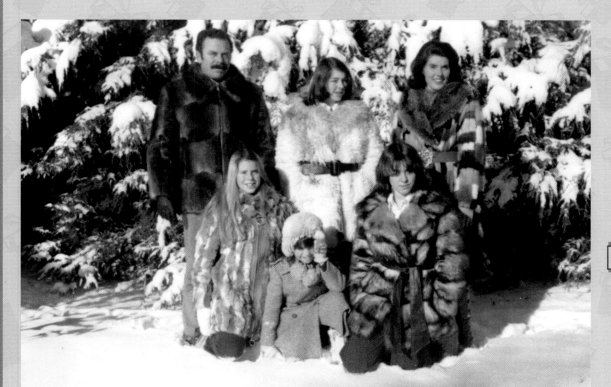

This family, meet PETA. PETA, meet this family.

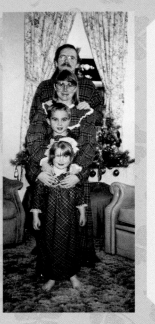

HOLIDAY MATCHY-MATCHY

It's the time of year when all the kids are home and the family unit has never been more unified. What better way to show this than by making sure everyone is equally humiliated?

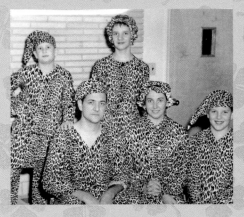

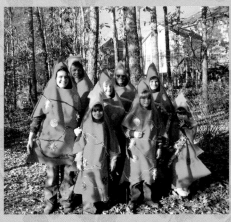

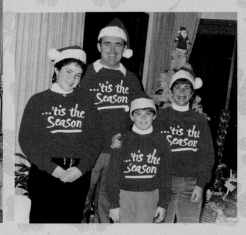

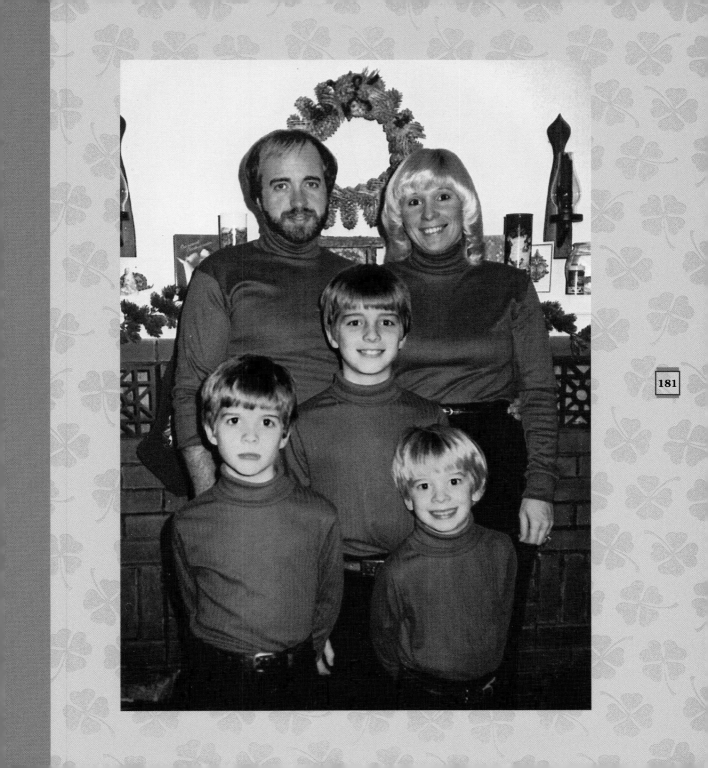

THE POPULAR KIDS

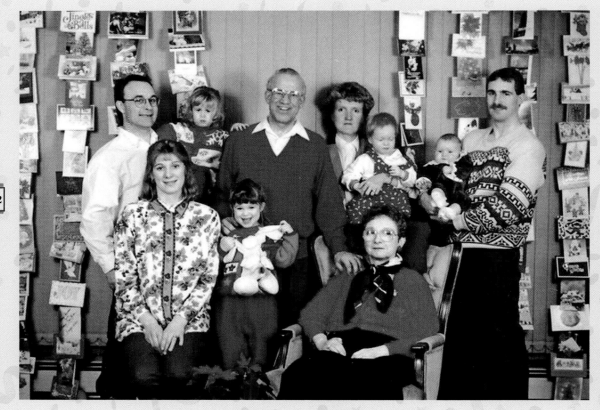

They didn't have to rub it in our faces.

GINGERBREAD GIRL

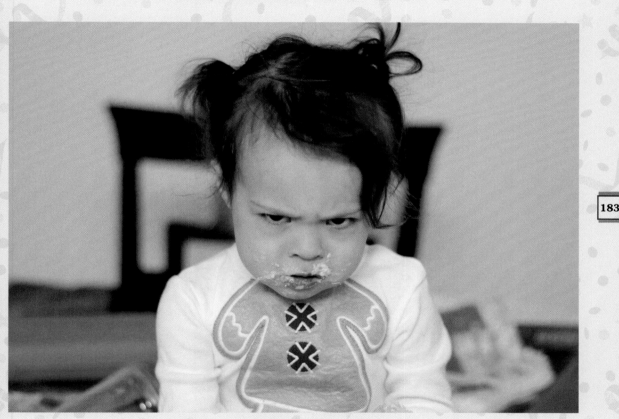

That's how the cookie crumbles.

BEHIND THE AWKWARDNESS

It was Christmas morning, and everybody except young Tim (middle) got a new bike. We, as parents, probably should have anticipated the reaction.

Scott
Keizer, Oregon

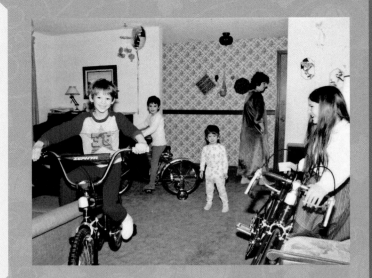

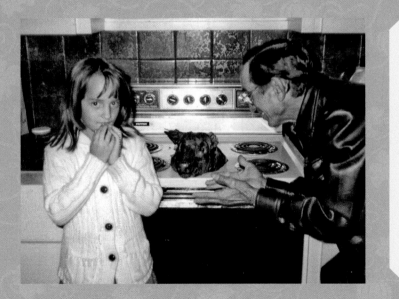

It is a tradition for Cubans to butcher and eat a pig on Christmas Eve. This is my grandpa making me pose with the remains of Christmas dinner while he talked to it! I was traumatized.

Maria
Marshfield, Missouri

This is Christmas morning in 1986 (I was ten) with my present—some bike parts. Apparently, at some point in the future I would be getting the rest of the bike.

Erin
Portland, Oregon

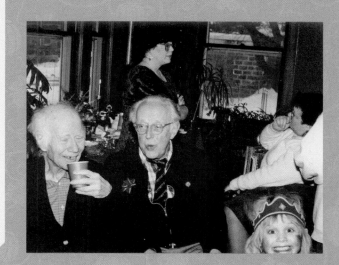

This was at my family Christmas party when I was about four. I had just received a makeup kit from Santa. That's my grandfather and a family friend on the left. Both of them were college professors. In my eagerness to have my facial masterpiece captured on film, I managed to pop up during a conversation that most likely would have been about literature or world travels.

Anne
Albany, New York

This 1984 picture was taken just two days before Christmas, and I made clothes to fit the festive scene. Since my little girl, Christina, was in her terrible twos, rarely sitting still for pictures at all, and our six-year-old son, Justin, wasn't quite as easily persuaded to pose for pictures as he used to be, I had to force everyone to record this magical Christmas moment.

Dianne
Springfield, Ohio

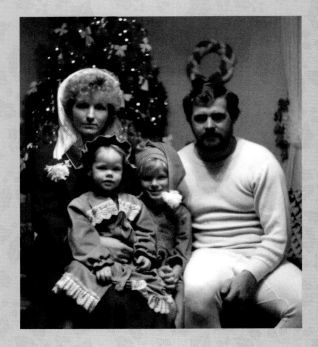

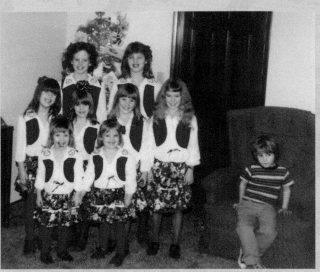

All of the girl cousins received these beautiful dresses for Christmas. Grandma got all of the girls together for a group pic, and cousin Brian in all of his jealous glory decided to photobomb it. We love him, but his bitterness in the pic is priceless.

Emilee
West Linn, Oregon

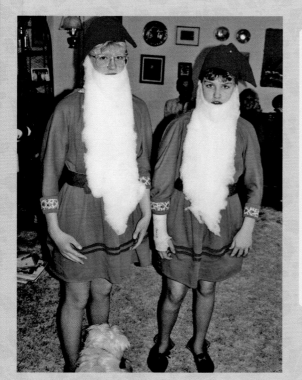

The photo on the left was taken in 1990 when I was thirteen. I'm the blonde one, and that is my sister, Theresa, on the right. My great-aunt Lillian made these elf outfits and the shoes for us. In fact, she did this every year (as you can see in the photos below), and although we protested, my mom would say, "But your aunt Lillian went to so much trouble to make them!"

Sara
Vadnais Heights, Minnesota

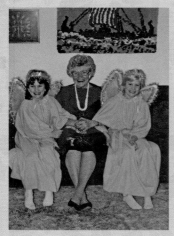

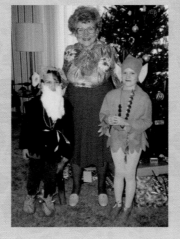

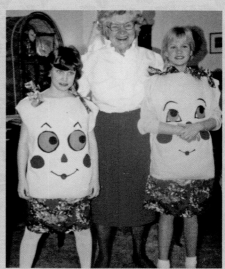

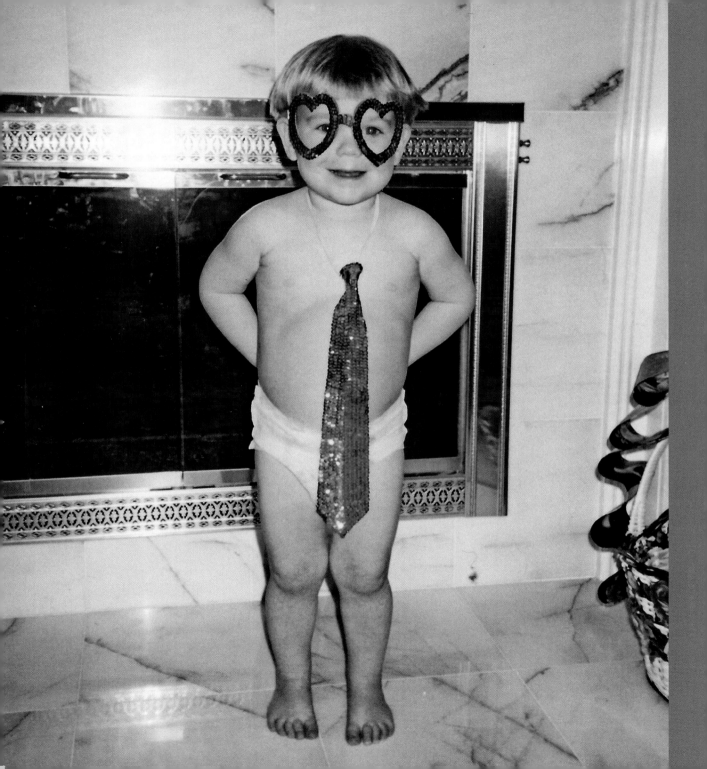

10

More Holiday Cheer

O ne of the great things about the holidays is that just when you're finished celebrating one, there's another right around the corner. While we couldn't devote a chapter to every major holiday, here are some others that we didn't want to leave out.

ST. PATRICK'S DAY

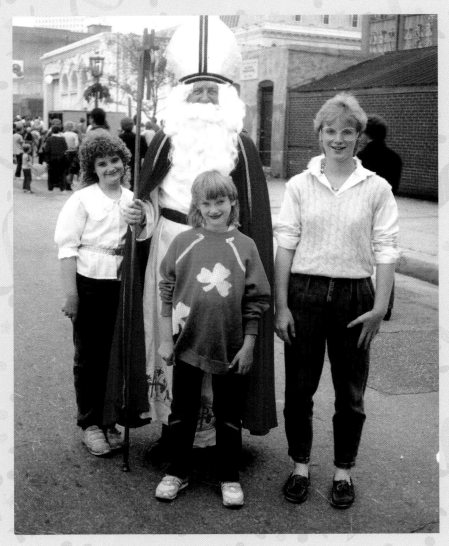

The holiday mascot is still in development.

NEW YEAR'S EVE

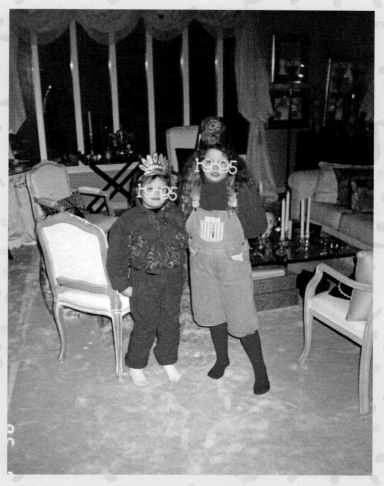

This is why "Party like it's 1995" never caught on.

ARBOR DAY

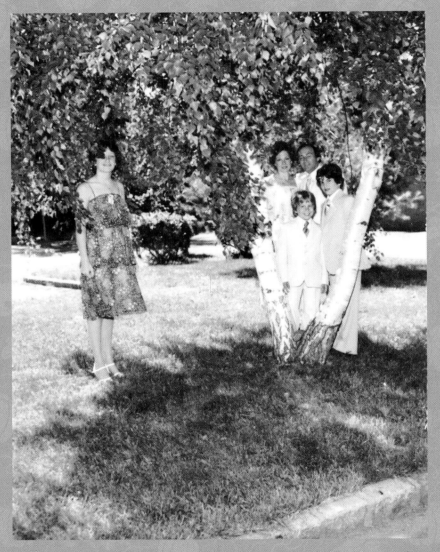

The beauty of the tree can be appreciated from any angle.

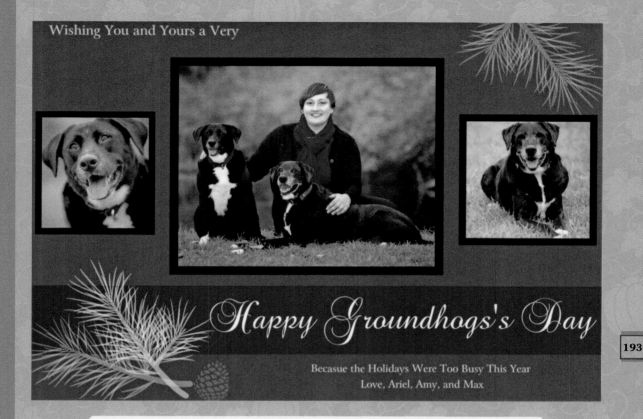

Wishing You and Yours a Very

Happy Groundhogs's Day

Becasue the Holidays Were Too Busy This Year
Love, Ariel, Amy, and Max

BEHIND THE AWKWARDNESS: GROUNDHOG DAY

Being seemingly forever single and having recently moved to Indiana from Virginia, I had these pictures taken for Christmas cards but missed getting them in the mail, so I did the next best thing! Unfortunately, I can't spell and sent this to my friends, family, and coworkers.

Ariel
Indianapolis, Indiana

CANADA DAY

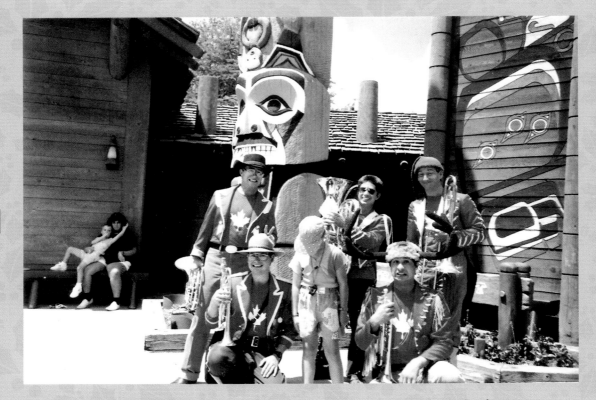

She was still coming to terms with her inner maple leaf.

MARDI GRAS

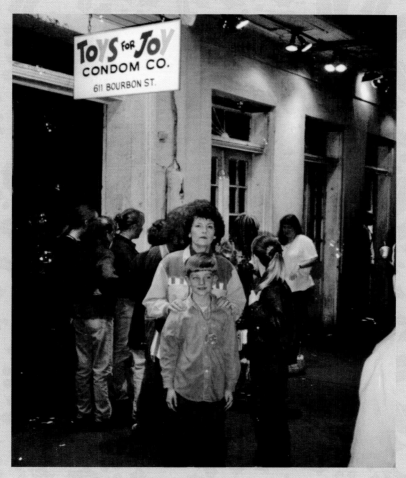

Mom can be a little overprotective.

EARTH DAY

There is no greener act than recycling yourself.

OKTOBERFEST

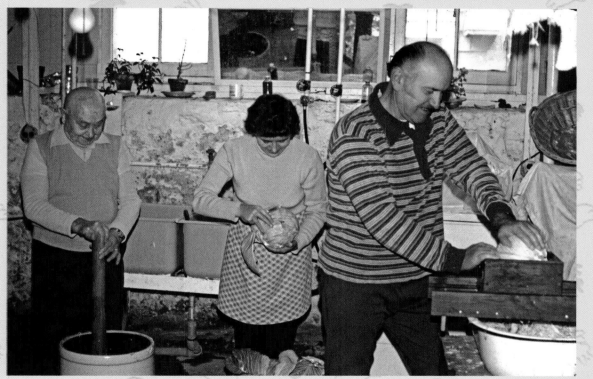

Time to make the sauerkraut.

Conclusion

No matter what the holiday is, it's a time for the family to come together and make one another uncomfortable. We've explored the most popular and widely celebrated holidays in this book, but there are many obscure ones that are even more cringe-inducing. So, we wanted to take this opportunity to recognize some of the little guys, and no, we didn't make any of these up. All of the holidays below have a validated origin source and/or sponsor, meaning someone actually takes responsibility for following through on observing this on a national or state level.

JANUARY

55-mph Speed Limit Day: 2
Balloon Ascension Day: 9
Learn Your Name in Morse Code Day: 11
Bubble Wrap Appreciation Day: 28

FEBRUARY

World Play Your Ukulele Day: 2
Ferris Wheel Day: 14
International Sword Swallowers Day: 23

MARCH

Registered Dietitian Day: 13
Awkward Moments Day: 18
Alien Abduction Day: 20
Bunsen Burner Day: 31

APRIL

International Beaver Day: 7
Barbershop Quartet Day: 11
High Five Day: 18
Plumbers' Day: 25

Sense of Smell Day: 27
Hospital Admitting Clerks' Day: 5
Trading Cards for Grown-ups Day: 8

MAY

Tuba Day: 3
Windmill Day: 10
International Migratory Bird Day: 11
Odometer Day: 12
Nylon Stockings Day: 15
Put a Pillow on Your Fridge Day: 29

JUNE

World Wind Day: 9
Ballpoint Pen Day: 10
National Canoe Day: 26

JULY

International Town Criers Day: 8
Take Your Houseplant for a Walk Day: 27
Walk on Stilts Day: 27

AUGUST

National Doll Day: 4
Halitosis Day: 6
International Bat Night: 24–25

SEPTEMBER

Eat Dinner with Your Kids Day: 25
Fish Amnesty Day: 28

OCTOBER

National Feral Cat Day: 16
National Mole Day: 23
National Pharmacy Buyer Day: 25

NOVEMBER

Area Code Day: 10
Push-Button Phone Day: 18
Flossing Day: 29
Computer Security Day: 30

DECEMBER

National Cotton Candy Day: 7
Dewey Decimal System Day: 10
Pick a Pathologist Pal Day: 13
Cat Herders Day: 15

Acknowledgments

W E WOULD LIKE TO THANK: All of the families who have so generously shared their awkward holiday photos with us; the Awkward Team: Blaire Bercy, Joe Hoyle, Jerry Domingue; our literary agent, Claudia Ballard; our licensing agent and eternal bar mitzvah boy, Kenny Abrams; Jamie Feldman, Jonathan Shikora, Greg Beattie; Pat Dunn, Carol Abramson; Benderspink; our official AFP photographer, Julia Varga; Eric Poses; the funniest person we know at 5:50 a.m., 6:50 a.m., 7:50 a.m.: Allie MacKay; and of course, we continue to be grateful to Kevin Mulhern at 94 WHJY for helping us launch the website in 2009; the team at Three Rivers: Campbell Wharton, Sarah Breivogel, Maria Elias, Elizabeth Rendfleisch, Anna Thompson, and Suzanne O'Neill, our one and only editor. We couldn't have made it through three books without her passion, support, and enthusiasm. And we'll always remember that initial letter she wrote to us and the photo that came with it. She will always be our lucky star.

MIKE BENDER WOULD LIKE TO THANK: My loving and supportive wife, SuChin, and my son, Kai, who doesn't understand what Daddy does and still won't when he's older. My parents, Jules and Rebecca, who continue to make me cringe in the best kind of way. To Chris and Kristi Bender, Emmy and Selma Bender, and my brother-in-law, Suhyun Pak. To the rest of my family and friends, whose unwavering support for a guy who posts wacky photos every day means more to me than you'll ever know. And finally, to Kenny and Selma Furst—my grandparents, my friends, my teachers, and the most amazing people I know.

DOUG CHERNACK WOULD LIKE TO THANK: My wife, Amy, for her love, encouragement, and insistence on still dressing our family in matching outfits for our annual holiday card. My children, Ravi and Violet, for making every day special and for giving me an excuse to leave any family get-together early. My parents, my brother, my sister-in-law, and the rest of my family for their love, their support, and for having a sense of humor about being a part of the original awkward family. My friends Matt Hinton and Alan Donnelly. Anthony Padnos for introducing AFP to the five and under crowd. And to all of my family's uncomfortable holiday moments, including the competing Thanksgivings, the cousins' table that was in a separate room from the rest of the family, and all of those depressing trick-or-treats where nobody was ever home in our neighborhood.

Photo Credits

Page 12: Lisa Winston & Stephanie; page 14: Lynn Ann S.; page 15: Woodside family; page 16: Maria Chaney; page 17: Lexi; page 18: Grace (top), Karen (bottom); page 19: Mr. & Mrs. T.; page 20: anonymous; page 21: Colleen McGinn; page 22: the Farringtons; page 23: Scull family; page 24: anonymous; page 25: the Scholls (top right), Gragg family (bottom left), Donald Harbin (bottom right), Embarrassed Daughter (top left); page 26: Josh L. Crump; page 28: Gabrielle Stuehm; page 29: Nicholas C. Miller; page 30: Phil; page 31: Dana; page 32: Shara (top), Solanah (bottom); page 33: Carol (top), Kirsten (bottom); page 34: David Campbell; page 35: Nicki Mandel; page 36: Julie; page 37: anonymous; page 38: anonymous (top left), Lindall family (top right), Dallas Caulkins (bottom right), Daniel Mulligan (bottom left); page 39: Gwin family; page 40: Jared Blair; page 41: Katie Ross; page 42: Sara Murphy; page 43: Meredith (top left), Terrie Nash (top right), Cathy (bottom right), Renee & Morgan (bottom left); page 44: Maureen (top left), Candice Fry (top right), Kristopher (bottom right), Betsy Neumann (bottom left); page 45: anonymous; page 46: Michelle Hakenson; page 48: anonymous; page 49: anonymous; page 50: anonymous; page 51: Allison; page 52: Kim Fuller Photography, Inc. (top left), Joni Moore (top right), Andrea Whitmer (bottom);

page 53: anonymous; page 54: Jeff Robbins; page 55: Sean McBriarty; page 56: Stephanie Strausser; page 57: Paul Pennington; page 58: Megan Henirich; page 59: Jenny Glonek; page 60: Lisa (top), Emma Hurst (bottom right), anonymous (bottom left); page 61: Darrin Wesenberg; page 62: Fonseca family; page 63: Amelia Hunnicutt; page 64: anonymous; page 65: Rissa H.; page 66: anonymous; page 68: Adam O.; page 69: Tom Edney; page 70: the Shelton family; page 71: Doni Smith (top), Christopher Paul (bottom right), Jax Adele (bottom left); page 72: Dunlap family; page 73: B. Smith; page 74: Pimentel 1978; page 75: Reel family (top), Sasha Strand (bottom right), Hollye Bourguignon (bottom left); page 76: anonymous; page 77: anonymous; page 78: anonymous (top right), Linda Oman (bottom right), anonymous (bottom left), Robert Bareil (top left); page 79: anonymous; page 80: Dad & Daughter; page 81: anonymous; page 82: the Rivers family (top right), Dad & Sammy Losinski (bottom right), Jeremy Tate (bottom left); page 83: Nina; page 84: Al; page 85: Michal Malo; page 86: anonymous; page 87: the Arnold family; page 88: Derek Larson; page 90: Portolos family; page 91: Davis Ladies; page 92: Tom; page 93: Susanne Bergman; page 94: anonymous (top), Julie Boehme (center right), the True

family (bottom right), Celeste Yager-Kandle (left); page 95: anonymous; page 96: anonymous; page 97: Valerie Stewart; page 98: anonymous; page 99: Chris (top), Treg (bottom); page 100: the Bloodsworth family; page 101: Matt Abbato; page 102: Bob Bond, lotsashots.com; page 104: Cindy Arnold; page 105: anonymous; page 106: Arie Edmund, Hiller; page 107: Amber; page 108: Mike McCamon; page 109: Bettina Souders (top), anonymous (bottom right), the Millers & the Durans (bottom left); page 110: Sheena; page 111: April & her grandparents; page 112: Stacy Hally; page 113: anonymous (top), Maryam Riazian (bottom right), Joe Truppo (bottom left); page 114: Sean Carlson & Erin N. Payton; page 115: Alex Bauwens; page 116: anonymous; page 118: Reg Lapham; page 119: Hermon family; page 120: anonymous; page 121: the Hardwood family; page 122: Julie Carroll; page 123: Michelle (top), Ava (bottom); page 124: Lonnie (top), Veronica (bottom); page 125: Robbie (top), Maggie (bottom); page 126: Ellie (top), Grace (bottom); page 127: anonymous; page 128: anonymous; page 129: the Terrill family (top right), Holland Whiteburch (bottom right), the Higbee family (top left), Olivia Claypool (bottom left); page 130: Kari Jo McMichael (top), Jason Byers (bottom right), Anne Rau (bottom center), the

Goldyn family (bottom left), Andy Jeter (left center); page 131: Kenny Ludlow; page 132: Kelly Proctor; page 133: Barb Tourtillotte; page 134: anonymous; page 135: Ali McKay; page 136: Jason Haynes; page 137: anonymous; page 138: Saulnier Thanksgiving Treaty; page 140: M.J. Dunne; page 141: the Adams family; page 142: anonymous; page 143: Gillian Rowe McNamara; page 144: anonymous; page 145: the Formby family (top), Ryan (center), Miranda Cooper Justus (bottom); page 146: David & Lisa Pearson; page 147: Mike Moran; page 148: Nakamichi; page 149: Valerie Fellows (top right), Casey Alexander (bottom right), Jesse King (left); page 150: Kaitlyn Roden; page 151: James Davis; page 152: Shawna Gurgul; page 154: Heather Woroschinski; page 155: Cory; page 156: Jason; page 157: Lauren Blanchard; page 158: anonymous; page 159: Grace (top right), Joel Gallen (center right), The Chernacks (bottom right), Jessica Winston & Ernie (bottom left), Mollie (top left); page 160: the Tippett family; page 161: Jamie Zobrist of Jamilia Jean Photography; page 162: Calvin Meuser; page 163: anonymous (top right), the Rummingers (bottom right), Alysha Wallace (bottom left), Kate Brunner Quinn (top left); page 164: Amy Bradley-Hole; page 165: Rhett Lowry; page 166: Heather Fye Waite (top right), Rick Maisonneuve (center right), Signe Larson (bottom), Ben Shannon (top left); page 167: Elizabeth Castle (Smith) (top), anonymous (bottom right), the Hille family (bottom left); page 168: Cyndi Thomasson; page 170: Bud Moore; page 171: anonymous (top right), Julia (bottom right), anonymous (bottom left); page 172: Amanda Barbarito; page 173: Tim MC; page 174: Chauncey Secrist; page 175: Mayor of San Juan; page 176: Carly Devilian; page 177: anonymous (top right), Sarah Leduke (bottom right), the Austins (bottom left); page 178: the Sullivant family; page 179: anonymous;

page 180: Rae (top right), Sara Kreps (center right), the Frank family (bottom right), Brian Butler (bottom left), anonymous (top left); page 181: anonymous; page 182: anonymous; page 183: Eloise; page 184: Scott (top), Maria (bottom); page 185: Erin (top), Anne (bottom); page 186: Dianne (top), Emilee (bottom); page 187: Sara (all); page 188: Kelly Proctor; page 190: Catherine Palmore; page 191: Erika Lambert; page 192: Rebecca Brown; page 193: Ariel & Brandon James Photography; page 194: Sarah Satton; page 195: the Whitakers; page 196: Parker B. Bennett; page 197: Guenther; page 198 (collage): Alex Bonson; Alex Cowper; Alex Webb; Alexa Luke; Alexandra L.; Alicia; Alison Amarnick; Allie MacKay; Amber (Schmidt) Waldeier; Amy Owens; the Anderson family; Angela Huerta; Anne Deck; Ashley Storrie; Averie Huffine; the Beery family; the Best family; Beth Dowty; the Bosserman family; Brandi Serrano; Brent Ray; Brian E. Smith; Candi Carpenter; Carlos Aguayo; Catherine Prime; Cheryl Wagner; Christy D. Beal; Claire; Claire; Claire Farrington; Clara McNulty; Clyde; Dad & Son; Dan Witus; Dana Sharff; Danielle Donovan; the Daussat family; David Campbell; Dawn Yengich; Demec family; Donny Hadfield; Elea Colot; Eleanor May; Emily Clisch; Emma Lynne Hansen; Eric Edelman; Eva & Armand Lefebvre; the Flemins family; the Frazier family; Gary Moore; the Goularte family; Grace M. Pollert; the Haller family; the Hamann family; Hannah Abrams; the Hargett family; Heather Kilpatrick Smith; Jan Taedo; Jen & Eric E.; Jennifer Boane Cone; Jennifer Flores; Jennifer Knode; Jennifer Park Jevons, Dan Jevons; Jenny Glonek; Jenny Sims; Jessica Wahl; Jillian Quail; Joan Kingsbury Pagliarulo; Joy Skiver; Julia McNally; Julie & Jamie Kane; K. Schelling; Kara; Kathy; Katie Johnson; Katy Foraker; Kayla Kuhn; Kayley Jones; Kelli S.;

Kelly; Kelly Kirk; the Kent family; Kim McCormac; Kristin Mitchell; Kyrsten Pratt; Lacey Bruner & Lindsay Barker; Laura Siitari; Lauren Foye; Leeandra Dittman; Lindsi Boynton; Lissa Chivester; Lynn Ann S.; M.J. Falk; Mallory; Mary Grace G.; Mary Lea Williams; Matt N.; Matthew Perala; Maureen McNulty; Maurice Coyle; the McKinlay family; the McMordie family; the McGaugh family; Megan Stacy; Megen D.; Michael Bellman; Michelle Bredehoff; Mike Moran; Molly Click; Monique Maunch & Denise Propst; Mother Dianna; Natalie Pozo; Nichole Monahan; Niki Martin; the Owens family; Patrick Smith; Paul Ellsworth; photographer, Lorin Martin; the Power family; Rachael Meserve; Rachel Trembley; Rashelle Frashner; Rikki Judice & Dane Broussard; the Rivera/ Wilson family; Robin Crowley; Roland Hunter; Rory; Samantha Meeks; Sancho Frank & family; Sara Kreps; Sarah Beri; Sarah C.; Sarah Hunt; Shelley Gayler; Sly Sisiter; the Stack family; Sydney Dever; Tara; Teddy Iten-Scott; the Andersen, Czinger & Dunn family; the Attridge Triplets; the Baby; the Backer Girls; the Dansforths; the Enos & Pereira family; the Frank family; the Galvin family; the Hoppe family; the Houston Family; the Hunt & Fritz family; the Junco family; the Keane & Bowden family; the King family; the Kissell family; the Lacey Boys; the Lambert family; the McGrath, Glasgow & Talkie clan; the Moffatt family; the Payne family; the Schreiner family; the Smith family; the Tremuth family; the Walton family; the Washburn Cousins; the Watson family; the Wise family; Toba Lynn; Tracy Feingold; Valerie O'Glain; Veronica Curtis; Walter & Andromeda Cornás; the Wells family; Wendy "the Champ" Wagner; the White family, Indianapolis; the Wilson family; Yvonne Zipter & Grandparents; page 201: Eleanor O'Neill; page 205: Mike Bender (left); Doug Chernack (right).

About the Authors

Mike Bender is a screenwriter whose credits include *Not Another Teen Movie* and the MTV Movie Awards. His favorite awkward holiday memory was watching his mother stay up all night to make seating cards for the Thanksgiving table and then watching the entire family ignore those seating cards.

Doug Chernack has created and produced television shows for E!, Fox Sports, and The Golf Channel. His most cherished awkward holiday moment was getting egged in his robot costume on Halloween.

CONTINUE THE CRINGE-WORTHY LAUGHS

"Painful, regrettable, horrifyingly awesome snaps of family bonding—
you will laugh so hard that people in adjoining offices will ask
what's wrong with you."
—*Esquire*

SUBMIT YOUR AWKWARD BABY PICS!

We've all seen cute and cuddly baby pics, but what about all
of those awkward photos of babies drooling, scowling, and
flipping the bird? In our next book, AFP sets out to prove
that we were all born to be awkward, and we want you to be
a part of it!

**Please submit your awkward baby photos (ages newborn
to 4) to awkwardfamilyphotos.com/submit.**

THREE RIVERS PRESS
NEW YORK